SURREALIST
DRAWINGS

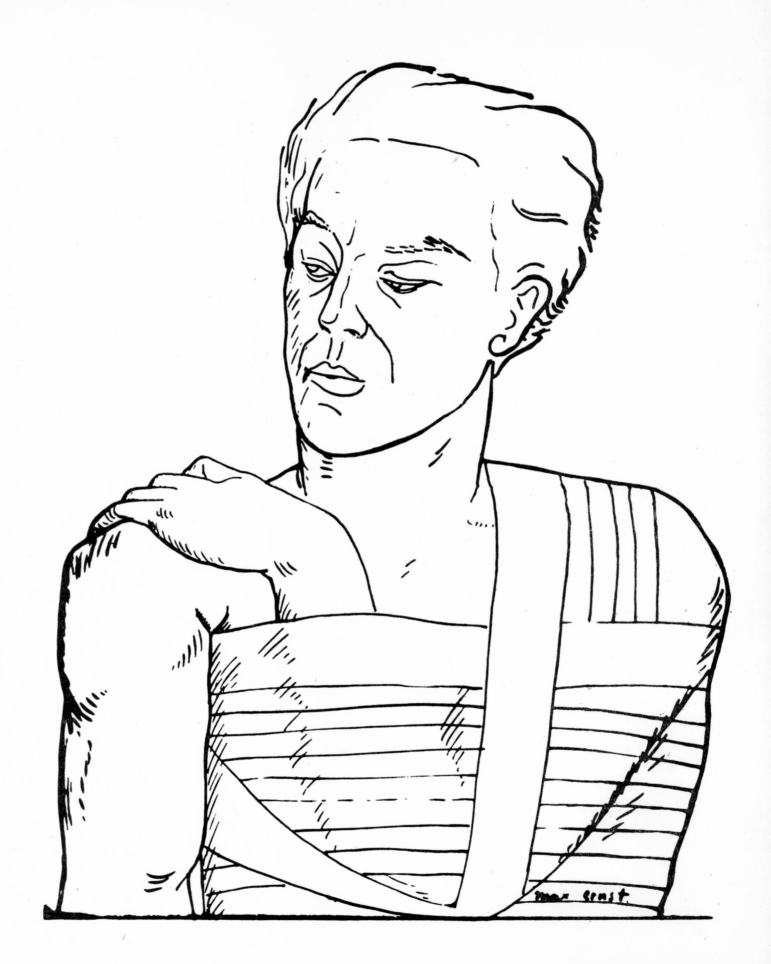

SURREALIST DRAWINGS

TEXT BY FRANTIŠEK ŠMEJKAL

OCTOPUS BOOKS LIMITED

MAX ERNST: *Portrait of André Breton*, 1924 (frontispiece)

Translated by Till Gottheiner
Graphic design by Karel Šafář
© 1974 Artia, Prague
Text © 1974 František Šmejkal
Illustrations: No 5 © 1974 Mit Genehmigung der Nymphenburger Ver-
lagshandlung GmbH, Munich; Nos 6—7 © 1974 G. de Chirico, Rome;
frontispiece and Nos 8, 9—12, 28, 29—31 and pp. 18, 47 © S.P.A.D.E.M.,
Paris; Nos 13—15 and pp. 13, 23 © 1974 A. Masson, Paris; Nos
16—17, 20—22, 35—37, 38 and pp. 10, 23 (H. Arp), 26, 29, 33, 35 ©
1974 by A. D. A. G. P., Paris and COSMOPRESS, Geneva; Nos 18—19
© 1974 Pierre Matisse Gallery, New York; Nos 23—26 and p. 30 ©
1974 S. Dali; Nos 32—34 © 1974 SABAM, Brussels; No 39 and p. 36
© 1974 W. Paalen; No 40 © 1974 R. Oelze, Posteholz (Federal Republic
of Germany); No 41 © 1974 K. Seligmann; No 42 © 1974 J. Hérold,
Paris; Nos 43—45 © 1974 Toyen, Paris; Nos 46—48 and pp. 39, 41
© 1974 Toyen, Paris; Nos 49—51 © 1974 František Muzika, Prague;
Nos 52—53 © 1974 A. Janoušková, Prague; No 54 © 1974 V. Wachs-
manová, Prague; Nos 55—57 and p. 43 © 1974 Matta, Paris; Nos 58—59
and p. 44 © 1974 W. Lam, Paris; Nos 60—61 © 1974 B. Tikalová,
Prague; No 62 © 1974 J. Istler, Prague; No 63 © 1974 M. Medek, Prague;
No 64 © 1974 Brockstedt, Hamburg; No 65 © 1974 Jean Fournier,
Paris; No 66 © 1974 M. W. Svanberg, Stockholm; p. 21 © 1974 Man
Ray, Paris; p. 40 © 1974 Nadine Šíma, Paris; p. 44 © 1974 A. Gorky;
p. 45 © 1974 J. Camacho, Paris.

First published 1974 by
Octopus Books Limited
59 Grosvenor Street, London W 1
Reprinted 1975
ISBN 0 7064 0194 8
Printed in Czechoslovakia
2/02/11/51

CONTENTS

Introduction 7

The Theory 8

Precursors 13

The Founders 17

The Expansion and Occultation of Surrealism 32

Czech Surrealism 36

Surrealism in Exile 40

The Last Surrealists 42

Notes 45

Select Bibliography 47

List of Text Figures 48

List of Plates 48

INTRODUCTION

In the last few years a number of books on Surrealist art have been published, but not a single one pays systematic attention to drawing. Nevertheless there can be little doubt that drawing as a classical technique played a vital role in a movement as innovatory as Surrealism. However much Surrealism tried from its early stages to confute traditional concepts of art, in the visual arts particularly it could not avoid traditional techniques, though they were used for a novel purpose. As the movement gathered force, certain new means of expression were discovered that perfectly matched its requirements and aims. Thus drawing techniques came to include frottage, decalcomania and fumage. To this might be added the non-traditional use of drawing as part of a group game called "Exquisite Corpse". It was popular mainly in the early years of Surrealism. New means of expression of this kind were freely adopted, but they did not supersede the old drawing techniques, which, right to the end, were still widely used by Surrealists.

Drawing indeed proved to be one of the purest media for expressing the two basic notions of Surrealist psychic automatism: it served as an immediate tool for graphic automatism, since it was less encumbered than other media with aesthetic considerations. This automatism was a parallel in art to verbal automatism. Furthermore, drawing was the basic medium for the instant recording of dream images, which formed a counterpart to written records of dreams. Both these aspects stood out clearly in the early stages of Surrealism. They underwent a variety of changes as the movement evolved, forming two focal points round which other means of expression gravitated, each modified by the personality of the respective artists.

Drawing did not play an equally important role in the work of all Surrealist painters. For some artists it served merely as a subsidiary tool for jotting down unconscious ideas or profound psychic impulses as soon as they arose, while others preferred drawing as a medium for final expression. Several Surrealist painters used it little or not at all.

In this book individual artists will not be discussed in relation to their importance within the Surrealist movement, but according to the role that draughtsmanship played in their work and how it helped to create the new mental worlds opened up by Surrealism. In other words, our main criterion will be the originality and expressive force of each draughtsman. A large number of general books on Surrealism give a detailed history of the movement. We therefore propose to omit this and merely set down some of the basic theoretical problems that are essential to a proper understanding of the meaning of Surrealist drawing.

THE THEORY

In 1930 André Breton showed remarkable foresight when he wrote in his *Second Surrealist Manifesto*:

"Let me say that Surrealism is still in the period of preparation, to which I hasten to add that it may well be that this period will last as long as I do myself... The fact is that, roughly speaking, these preparations are of an 'artistic' order. Nonetheless, I foresee that they will come to an end, and that then the revolutionary ideas that Surrealism conceals will emerge to the sound of a loud explosion and will then flow freely."

Today we can indeed say that Surrealism lived and died with André Breton, and that his lofty prediction came true almost to the letter. Breton founded Surrealism and defined its substance, its meaning and its aims. He was the leading personality in its heroic period. It was he who upheld its continuity and coherence at a time when most of the leading figures were leaving it one by one, and when other trends took over the initiative in European art. Shortly after Breton's death in 1966 the Surrealist movement broke up as a result of strong internal dissension and disagreements that reached their climax in 1969. At that time Jean Schuster, a leading figure of the movement after the war, announced the end of group work and declared that the historic phase of Surrealism was over: "...Historic Surrealism would stake a special claim in having a beginning and not having an end."[1]

The end of Surrealism was not brought about simply by dissension among the members and the gradual drying up of their activity. One of the main reasons for the dissolution of the group was the partial fulfilment of the second part of Breton's prediction, in the form of the Paris students' revolt of May 1968. Under the slogan "L'imagination prend le pouvoir" ("Imagination takes over") the students turned against the repressive social institutions and by leading up to a revolutionary situation tried to implement the Surrealists' demand for a parallel change in the world and in man's inner life. Nor was that the only way in which Surrealist ideas were implemented.

As Surrealism lost its significance as an organized movement in art, its influence began to penetrate to other movements where the problems it had set existed in a different form. We might, by way of example, cite Tachism in Europe and Action Painting in the United States, which were new developments in graphic automatism; or in the sixties, the renaissance of the object in various currents of world art. With the end of historic Surrealism Breton's period of "preparation of an artistic order" drew to a close. But Surrealist ideas continue to exist in what Jean Schuster has called "eternal Surrealism", meaning a special disposition among some people to express, without the limiting straitjacket of group orthodoxy, a certain attitude and problems that were always inherent in Surrealism.

Today we can regard Surrealism as a finished chapter in the history of art, on which its works and revolutionary ideas have left a profound mark.

Let us deal first with the ideas, for Surrealism was a movement where theory played a significant part, often preceding and in a decisive manner determining artistic creation. Surrealism was not only a special trend in art. It was a whole attitude to life, a spiritual movement expressing itself in every available medium. Therefore, it was not necessarily merely a theory of art that influenced the form and character of paintings and drawings. Many basic concepts of Surrealist theory had a general validity for every means of expression.

When Surrealism was established in 1924 as a homogeneous group, the majority of its members were poets, and the few painters who pledged allegiance at the beginning had only a marginal status. Not a single one of them was listed among the "founding members", who by their signatures identified themselves with the definition of Surrealism as given in Breton's *First Surrealist Manifesto*. Furthermore, in the entire manifesto setting down the basic principles of the movement only one small footnote touched upon the problems of the fine arts, in which Breton cited a very mixed group of painters in whose works he detected certain points of contact with Surrealism. Among its historical and immediate precursors he named only Uccello, Seurat and Gustave Moreau; among contemporaries he referred to Matisse, Derain, Picasso, Braque, Duchamp, Picabia, de Chirico, Klee, Man Ray, Max Ernst and André Masson. In other words, a strange mixture of Fauvists, Cubists, ex-Dadaists and independent artists. This was a sign that Breton himself had only a vague concept of the potential future of Surrealist painting. As late as 1925 the possibilities of its existence were still in doubt, though when we look back at it today, we realize that a number of typically Surrealist works had been produced by that time. Pierre Naville wrote in the third number of *La Révolution Surréaliste*: "No one remains unaware of the fact that there is no such thing as Surrealist painting. It is clear that pencil marks resulting from chance gestures, a picture which sets down dream images, and imaginative fantasies can none of them be described as Surrealist painting." Naville's denial of the existence of Surrealist painting was in tune with his efforts to preserve the revolutionary, anti-art element that Surrealism inherited from Dadaism. This attitude aroused sharp disagreements between the majority of the members. Breton reacted in a series of articles compiled in 1928 in his book *Surrealism and Painting*, in which he tried to outline the prerequisites for the development of Surrealist art and gave the main characteristics of the work of the numerous artists working in this field by then. The entire book is written in Breton's typically light and lofty style, where poetic imagery takes the place of analysis and binding

8

definitions are avoided. More exact formulations are found in Breton's later work, where he dealt with broader problems of art, examples being the lecture "The Surrealist Situation of the Object" (1935), *The Artistic Genesis and Perspective of Surrealism* (1941), and several other shorter articles. A comparison between all these studies and the manifestos allows us to deduce certain basic principles underlying the otherwise flexible theory of Surrealist art.

It has been said that Surrealism was not merely a trend in art but a spiritual movement, following up the Dadaist revolt against the old world and its social institutions, against its utilitarian and rational manner of thinking, and last, though by no means least, against literature and art as they portrayed that world. But Surrealism did not remain content with anarchistic negation. It therefore tried to induce a radical change in the existing state of affairs — a change of the world brought about by a revolutionary movement — an inward change in man, which was to accompany changes in the social order. A "crisis of consciousness", a crisis of all old moral and intellectual values, was to be roused with all the means available. It was to go hand in hand with the liberation of all suppressed faculties of the human spirit and with the creation of a new, broader and freer consciousness. In attaining all this, the Surrealists chose the path opened up, at the beginning of the century, by Sigmund Freud, a path that had previously been travelled only by a few isolated and far-seeing men, a precipitous and dangerous path leading towards the most profound and hidden spheres of our psyche.

This new and unknown domain, the existence of which had been spelled out by Apollinaire, was to be thoroughly investigated and mapped out by the collective endeavours of the Surrealist artists. The poets were to rediscover the secret of a universal, forgotten language of symbols, which speaks to us through our dreams, and some fragments of which have survived in fairy-tales, in legends and myths. The painters were to bring to light the hidden and previously unseen landscapes of the mind. They were to learn the laws of novel poetic compositions, contradicting the logic of everyday life. At the same time, they were to depict in graphic terms the faintest tremblings of signals sent out from the depth of our unconscious. André Breton sketched out this path in his *Second Manifesto*: "...The idea of Surrealism simply leads to the complete recuperation of our psychic strength by a means which is no less than a giddy descent into ourselves, the systematic illumination of hidden places and the gradual blackout of other places, the perpetual walk in the midst of forbidden regions..."

Surrealism was not, however, concerned merely with the discovery of these hidden places of our psyche, but with the recognition of their significance, function and mechanics, their interpretation and finally their integration into our conscious life. Breton laid this down clearly in his *First Surrealist Manifesto*: "If the depth of our spirit encompasses strange forces capable of increasing those on the surface, or of fighting victoriously against them, then it becomes necessary to capture them, first to capture them in order to submit them, if necessary, to the control of our reason."

Typical in this respect is the Surrealists' attitude to dreams, which held a key position among their interests. Initially, in the pre-Surrealist "sleep period", dreams were merely a novel source of inspiration providing interesting poetic material acquired either through automatic writing during hypnotic sleep, or as an instantaneous record of dreams experienced at night. The Surrealists-to-be were stimulated by their irrationality, their fantasy and their spontaneous poetic expression. But within a short time Breton was posing in the *First Manifesto* the question of whether it might not be possible to use dreams for the solution of basic problems of human life. He saw the main aim of Surrealist activity in the merging of dream and reality: "I believe in the future resolution of these two states — outwardly so contradictory — which are dream and reality, into a sort of absolute reality, a surreality, so to speak. I am aiming to conquer it..."

In the subsequent stage the aspect of interpretation was increasingly stressed, until in Breton's *Les Vases communicants* and in other writings he foresaw the complete merging and mutual influence of waking and dream consciousness, the temporary attainment of surreality in everyday life. But the conditions under which the Surrealists lived were not propitious for the realization of such a state, and it was attained in only a few works of art.

To this day the dream remains one of the outstanding unsolved questions to which the Surrealists drew attention. It is certainly not mere chance that one of the main tasks Jean Schuster laid before the Surrealists, who were no longer to continue their search as a group, but as individual artists, was the further investigation of the dream in respect to new scientific discoveries. These indicated that the dream might one day become a true guide to man's fate, just as André Breton had suggested half a century earlier.

The general principles of Surrealism were applied in the fine arts in a free and non-dogmatic manner and were never precisely defined, as stylistic conventions have been in the majority of other art movements. For that reason Surrealist art shows a great variety and cannot be reduced to a single formal common denominator. W. S. Rubin recently tried to characterize Surrealism, from the point of view of its formal structure, as biomorphism (Miró) and illusionism (Magritte) or a combination of these two components (Tanguy). But this is not entirely correct. It should be pointed out that similar stylistic elements can be found in several other trends of the time, such as Lyrical

JOAN MIRÓ: *Pastorale*, 1924

Cubism or *Neue Sachlichkeit*. It is, of course, true that some of the formal features found in the work of the leading Surrealist painters were in time conventionalized and were adopted by a number of followers within and outside the movement, thus giving the illusion of a style. But the fact remains that the majority of outstanding Surrealists expressed themselves, particularly in the early days, in extremely personal and therefore disparate ways. The adherence of individual painters to the movement can be deduced from their general attitude to life and the "moral asepsis" stipulated by Breton rather than from their artistic expression.

In the first and most basic work dealing with the problem of Surrealist art (Breton's *Surrealism and Painting*, 1928) one seeks in vain for a precise answer to the question "What is Surrealist painting?". Breton limited himself here to a very general outline of the situation in which the first Surrealist works of art came into being.

"A very narrow conception of imitation given as the aim in art is at the bottom of the grave misunderstanding which we see perpetuated down to our own day. ...It is a mistake to think that models can be taken only from the external world or even that they can be taken from there alone. ... In any case, it is impossible in the present state of thinking, and particularly since the external world seems to be increasingly suspect, to consent to such a sacrifice. If the work of art is to correspond to the necessity of an absolute revision of real values – on which there is general agreement today – it refers to a *purely inner model*, or does not exist at all. It remains to be seen what is meant by inner model..."

In reply to this question Breton again gave no definition, but listed the characteristic features of a number of

painters, from Picasso and de Chirico to Tanguy. From this it becomes clear that Breton's conception of the "inner model" is virtually limitless. It includes work that arose out of active waking imagination as well as dream and hypnagogic images, or other work in which the artist gave way to purely graphic impulses. The inclusion of Picasso, Braque and Derain, to whose Cubist work the laws of psychic automatism can hardly be applied, can be explained by Breton's respect for those who completely disrupted the form of the external model and led the way towards non-representational art.

Breton returned to the concept of the "inner model" in a lecture called "The Surrealist Situation of the Object", delivered in Prague in 1935. This time he replaced the term "inner model" by the expression "inner image" or "pure mental image" and defined its meaning. First he tried to tone down the former sharp division between "inner" and "external" models by a more dialectical approach, stressing the interdependence of mental images and outward perception. In this way he linked the two diametrically opposed terms "perception" and "imagination":

"The apparently most free creation of Surrealist painters naturally cannot come into being except by a return to the 'visual remnants' deriving from outer perception. It is only in the work of regrouping these disorganized elements that their claim to what is both individual and collective appears. The potential genius of these painters rests not so much in the relative novelty of materials they use as in the degree of initiative they show in making use of these materials."

This new formulation of mental images includes — by stressing the work of regrouping elements — Lautréamont's principle of the accidental encounter of two remote realities in an irrelevant setting (an umbrella and a sewing-machine on a dissecting table). This principle was to become one of the main slogans of Surrealist imagery and its application can be found in numerous pictures, drawings, collages and objects.

Breton produced a slightly different conception in *The Artistic Genesis and Perspective of Surrealism* (1941) which is among the best he wrote on the fine arts. To some extent he revised certain opinions he had expressed in *Surrealism and Painting*. Breton again mentions the "inner model" but only as a milestone dividing the era of imitative art from that of non-imitative art. He distinguishes two main streams in contemporary Surrealist art, one derived from graphic automatism and the other from the setting down of dream images. These terms were not new. They can be found in many of Breton's earlier writings, though there they usually come under the common denominator of psychic automatism and are defined in rather vague terms. What is new here is a more precise theoretical definition and the way they have been placed more correctly in their historical context. Both principles date from the very early days of the movement. They are derived from the first experimental Surrealist techniques, automatic writing and the recording of dreams, the original aim of which was not to create new literary work but to unravel the cloud of mystery that envelops our unconscious mind, its content and its functions. Breton again stresses the primary cognitive function of these techniques in his *Second Surrealist Manifesto*, where he accuses some authors of being satisfied with letting their pen run over the paper without following what is happening to them while they do so, or of compiling dream elements arbitrarily so as to make them more picturesque rather than to show the profound meaning hidden in them. These words can be applied to painting, too, and form one of the main criteria for judging authentic Surrealist work.

Though in the end Surrealism could not avoid becoming an art, Surrealist works were never merely a series of beautiful or bizarre decorative objects, the arbitrary depiction of forms or images. They either offered immediate evidence of the inner life of their creators or, conversely, provided a stimulus that roused the spectator's imagination and stirred echoes in the depths of his psyche. In this manner Surrealism exceeded the sphere of mere aesthetic perception, and the problem of beauty, that central concept of all aesthetics, remained entirely irrelevant. "A work of art cannot be considered Surrealist unless the artist strains to reach the total psychophysical realm, of which consciousness is only a small part," says André Breton in *The Artistic Genesis and Perspective of Surrealism*, adding that the direct route leading to these spheres is automatism itself. Graphic automatism is here defined as work that emerges without any deliberate intention on the part of the artist; not a single stroke is foreseen in advance, for they are all dictated by immediate impulses issuing from the artist's inner world. What we have here is not the setting down of pre-existing mental images, as was the case in the theory of the "inner model", but gradual emergence and recording of these images as the work proceeds. Since automatism gave rise to a large number of disputes and misunderstandings Breton tried to define it here as precisely as possible: "I maintain that graphic as well as verbal automatism... is the only mode of expression that fully satisfies the eye or ear by achieving *rhythmic unity*... It is the only structure that responds to the non-distinction — which is becoming better and better established — between sensory and intellectual functions, which is why it alone can satisfy the spirit."

Breton resorted here to a very general and rather hermetic formulation which can be interpreted freely. For he was beginning to realize that pure graphic automatism was achieved only very rarely, even in the works of its main representatives (Masson, Miró, Arp and Matta), mostly in their drawings, while their paintings involved elements of thinking and deliberate intention. Breton was willing to admit the intervention of elements alien to automatism,

but on condition that automatism would "at least flow below the rocks", or else the work of art would run the risk of being swept outside the limits of Surrealism.

The second main current in Surrealist painting, the recording of dream images, was related to psychic automatism, not at the stage when the picture came into being but at the moment of inspiration. While the dream image is ideally a pure product of the unconscious, recording it is a more or less mechanical process in which reason and aesthetic adjustments threaten to interfere. The setting down of the image often took the form of *trompe l'oeil*, and here lay its weakness, as Breton pointed out. He never really attempted to define this second trend specifically, merely drawing attention to the fact that it proved far less reliable than graphic automatism and involved a far greater risk of going astray. This did not prevent him from making it one of the main routes of Surrealist painting, leading from Giorgio de Chirico to Oelze, Delvaux and Bellmer. In fact few Surrealist painters derived direct inspiration from dreams, and most of the work Breton included can be ascribed to active waking imagination. In de Chirico's work dreams did play an important role, but in the work of the other Surrealist painters their influence can be detected only on isolated occasions and not always in the form of an immediate record of true night dreams. Max Ernst, for instance, drew inspiration from hypnagogic images, while Salvador Dali used controlled waking dreams and Paul Delvaux evoked the dream atmosphere derived from general dream experience rather than from any single dream episode.

Alongside these two main trends Breton admitted as legitimately Surrealist a number of other forms, ranging from René Magritte's speculative method of painting to the paranoiac-critical activity of Salvador Dali, which far outstepped his theoretical stipulations. This points to the non-dogmatic approach and open-mindedness of Breton's system, which, particularly in the early days, gave scope to personal initiative even if it offended the letter — though never the spirit — of Surrealism. These personal attitudes, which were never very widespread, will be discussed in connection with the work of individual artists.

ANDRÉ MASSON: *Lovers*, 1925

PRECURSORS

Surrealism originated as an innovatory and revolutionary movement that directly resulted from the Dadaist revolt. But its roots go back far into the past. While the Dadaist *tabula rasa* negated all preceding artistic values, Surrealism tried, in the first instance, to pick up some of the broken threads of the immediate past. The Surrealists acknowledged Lautréamont, Rimbaud, Jarry and Apollinaire as direct precursors of certain aspects of their work. In the *First Surrealist Manifesto* the list of potential Surrealists from the past included over twenty names. And the painters soon followed the poets. At first there were only a few, and in the *First Surrealist Manifesto* Breton named only Uccello, Seurat and Moreau, to whom we might add Gauguin and Redon, whom he mentions in one of his first articles devoted to the fine arts, in *Distances*, reprinted in *Les pas perdus* (1924). Gradually further names were added to this small group, often those of half-forgotten artists whom Surrealism, throughout its existence, was constantly to discover and rehabilitate. And it is directly or indirectly due to Surrealism that many others once again assumed their place in the history of art, examples being Caron, Arcimboldo, Monsú, Desiderio, Grandville and so on. Their numbers increased steadily until eventually in Breton's *L'Art magique* (1957) there emerged what we might call a parallel history of art, which shifted the hinterland of Surrealist painting far into prehistory. To this should be added the Surrealists' permanent interest in art produced by spiritualist media, by the mentally disturbed, by naive painters and by members of primitive nations.

For our present purpose it will suffice to discuss the work of a few nineteenth-century artists who in their drawings predicted some of the problems that were to be expanded and systematized under Surrealism.

The first is a pre-Romantic English painter of Swiss origin, HENRY FUSELI, who joined the Surrealist pantheon at a relatively late stage. But he assumed quite an exceptional position in it almost immediately. José Pierre, the theoretician of the late phase of Surrealism, considers that Fuseli is the only painter of the past apart from Bosch who "undoubtedly complies with the definition of Surrealist painting most completely"[2]. Fuseli's exalted imagination gave rise to dramatic pictures of human passion, filled with horror and tragic pathos. His imagination became embodied in magnificent drawings, which represent an intimate diary of his anxieties, dreams and erotic obsessions. As such it undeniably does justice to such an assessment, for the unconscious motivation of the majority of these works, although they are often skilfully masked as literary topics, is more than apparent. Nonetheless Fuseli's main contribution to modern art rests in the rediscovery of dream inspiration, a source that had almost vanished after the Renaissance.

"One of the most unexplored regions of art is dreams,"[3] Fuseli noted at the end of the eighteenth century. He pointed to the existence of an extensive hinterland of the mind, which the Surrealists set out to explore in detail. Fuseli himself was the first artist to undertake such exploration by means of dozens of pictures and drawings. Most of them were limited to illustrating someone else's dreams, chiefly literary or mythological ones, but in their artistic interpretation we can perceive Fuseli's close knowledge of the peculiar laws of dream life. His weird cycle *Nightmares* contains his own dream experiences, a symbolic expression of his own erotic urges, given in the transvestite form of women's dreams. His understanding of dreams as an expression of hidden and unconscious desires, mostly of a libid-

inous nature, as a spontaneous safety-valve for obscure instincts, as a gateway leading to a knowledge of the darker side of our life, made Fuseli a forerunner not only of Romanticism but also of Surrealism. His work derived from dreams, in particular the *Nightmares*, found a direct response in the achievement of a series of Romantic painters, graphic artists and even writers. A belated echo of this can be found in the work of Klinger and Munch, who indirectly handed on Fuseli's influence to Surrealism. Fuseli's drawings in particular, which are almost untouched by the conventions of the period, show us the artist's message at its clearest.

Another figure who, half a century after Fuseli, set out along the road later followed by Surrealism, was not a painter but a poet, VICTOR HUGO. His name can be found in the list of precursors of Surrealism in the *First Surrealist Manifesto*. At that time Breton was thinking mainly of certain aspects of Hugo's poetry, rather than his surprising and little known drawings. Today, on the contrary, Hugo's drawings, in which he anticipated some important discoveries of twentieth-century art, are becoming ever more significant. Victor Hugo drew almost all his life, even though this activity existed only on the margin of his poetry. "It amuses me between two stanzas," he wrote in a letter to Baudelaire. And perhaps it was for that reason that he managed to achieve such freedom of expression and such unprecedented versatility in his use of the most varied techniques. It is interesting to note that his drawings contain in embryo the two main techniques of Surrealism: graphic automatism and dream inspiration.

Hugo's work contains some drawings directly inspired by dreams, plus a large number of others created, as he himself admitted, "in hours of almost unconscious reverie"[4]. In those happy moments of passive drowsiness there arose out of the depths of his unconscious subjectively transformed memories of his travels. In his drawings, which were executed with whatever lay to hand — pen, brush, or a piece of matchstick, using Indian ink, soot, ink, even black coffee — they assumed the form of fantastic landscapes, hallucinatory silhouettes of castles, ruins, lighthouses and towers, or weird night scenes with gallows and hanged figures. Hugo's imagination played equally freely with the metamorphosis of objects, transforming a salt-cellar into a fountain set in a lake, a severed head into a moon, an eye into a planet, or expanding a mushroom to the monstrous dimensions of an antediluvian creature.

Hugo approached graphic automatism most closely in works that arose from the principle of chance. Many of his drawings came into being without his conscious intention, from a few accidentally sketched lines, ink spots or coffee stains which roused his imagination to more or less spontaneous creation; in the process the spots turned into weird creatures, faces, landscapes or objects. Apart from these interpreted drawings, in which Hugo "questioned his own subconscious" in the manner of modern Rorschach tests, as Breton remarked in his *L'Art magique*, he also left many others in a "raw" state. These non-figurative sketches were forerunners of Tachism, preceding it by a whole century. Hugo's numerous drawings contain many other levels of expression and technical discoveries, but we have no space to discuss this here.

The work of GUSTAVE MOREAU forms a bridge between Romanticism and Symbolism and was admired by the Surrealists from the very beginning. André Breton discovered him as early as 1914, when his work had virtually fallen into oblivion, and remained attracted to him all his life. His name figures in Breton's first list of precursors of Surrealism and he returned to him towards the end of his life with new emphasis: "The discovery of the Gustave Moreau Museum when I was sixteen conditioned my manner of loving for all times. It was here that I found beauty, love, revealed through certain faces, certain postures of women. The 'type' of these women has probably hidden all others from me. It was a complete enchantment."[5]

Apart from these purely subjective reasons, Moreau's historic position in European art also played a considerable role in this assessment, in particular his stance as a consistent defender of imaginative and spiritually motivated work in the middle of the Impressionist period. It has been said that Moreau was the greatest mythological painter of the nineteenth century (M. Jean) and that he managed to give back to mythological figures their original ability to fascinate (Breton). This was because Moreau — in contrast to his academic contemporaries — never conceived the myth as a dead event, an anecdote, but as a living parable. Like Fuseli, Moreau used mythological scenes as a pretext for expressing his own vision of the world. Hence his Salome, his Helena and his Dalida are not only evocations of historical or legendary figures but living beings, personifying certain features of eternal Womanhood. At bottom Moreau only ever painted the same one woman, who was for him a symbol of fate, of evil, of animal eroticism and of death. That is why they all look alike. In the commentary to his picture *Chimera* (1884) Moreau gave a thoroughly decadent definition of woman, close to Huysman's: "This island of fantastic dreams contains all forms of the passion, fantasy and caprices of Woman, Woman in her prime essence, the unconscious being, enamoured of the unknown, in love with evil in the form of perverse diabolical seduction"[6].

In Moreau's pictures men mostly symbolized the opposite qualities — reason, good, will-power, justice and so on. A recurrent theme in his paintings is sexual antagonism, the struggle between good and evil, represented as a conflict between the sexes.[7] The hidden motive behind most of these pictures is in fact compensation for his own sexual complexes (some authors even speak of his latent homosexuality), the sublimation of his own unconscious forces, em-

bodied, to facilitate communication, in mythological parables. In the course of the last half-century Moreau's varied and complex work has once more risen to the fore, and in the early sixties he was dubbed a precursor of Lyrical Abstraction and Abstract Expressionism, on the basis of some of his oil sketches and watercolours. Although the conclusions drawn by the initiators of this second rehabilitation (D. Ashton, M. Ragon) were somewhat hasty, they did draw attention to the purely formal aspects of his work, which had been overlooked by the Surrealists. In this new light some of his pictures began to appear too "finished" and dry, unconsciously influenced by the academic manner of their time. His importance began to be seen in the many preparatory studies and drawings in which he had managed to make full use of the expressive strength of pure colours and shapes. In some drawings, such as *The Temptation of St Anthony*, he was even inspired by the chaotic colour-structure, which he later concretized in the form of chimeras, grimacing heads, serpents, goats, as Victor Hugo had before him. This brings us back to Moreau's links with Surrealism, which are as clear in his drawings as in his paintings.

By contrast, ODILON REDON, though no less important, was merely an illegitimate precursor of Surrealism. While at first the Surrealists passed his work over in silence or heaped vague accusations of aestheticism or religiosity upon it, in the last stages of the movement their attitude turned into one of outright rejection. This rejection was formulated by Jean-Louis Bédouin[8], the spokesman of the orthodox wing of the Surrealist group, and even bordered on a denial of his historic importance. It was, however, put right the same year by André Breton, who in his *L'Art magique* ranged Redon's dream symbolism alongside Moreau's mythical symbolism and Gauguin's synthetic symbolism. A year later Breton included some of Redon's works in an exhibition of Symbolist drawings held by the Surrealists at the Bateau-Lavoir.

Today, when we can look upon Surrealism as a finished art movement, its links with Redon appear quite clear. He had a direct influence on some of the most eminent Surrealist painters via the work of his "black period", as has recently been shown in a painstaking comparative analysis by W. S. Rubin[9]. He also anticipated Surrealism in some features of his theory of art. If we look at Redon's work — particularly the drawings and prints dating from 1870 to 1900 — and his theoretical writings with a less prejudiced eye than Bédouin's, we can detect numerous points of contact. Redon was one of the first painters to realize that "fantasy is also the messenger of the unconscious" and that "nothing in art is achieved by the will alone. Everything is done by docilely submitting to the arrival of the unconscious"[10]. Redon submitted to it in long hours of dreaming and (even more often) in the course of his actual work. For it appears that few of Redon's works came into being as the result of preconceived mental images. More often his ideas were modified in the course of the work or were actually brought about by the first strokes of the pen without any previous intention. He worked out two specific approaches to stimulate his imagination. In one, direct inspiration was exerted by the material itself.

"I have a horror of a sheet of blank paper. It makes such a disagreeable impression on me that I become sterile, and it takes away all desire to work (except in a case ... when I set myself the task of depicting something real); a sheet of paper shocks me so much that I am obliged, when it is on the drawing board, to scribble on it in charcoal, pencil, or any other way, and such an operation gives it life. I believe that suggestive art owes much to the stimulus which the actual material exerts on the artist."[11]

Here we get back to the direct line that leads from Hugo's ink blots and Moreau's patches of colour, via Redon's scribbling, to Surrealist frottage and decalcomania.

The second way in which Redon stimulated his imagination involved the inspiration offered by a small, realistic detail which proved quite unimportant in the final work. "After the effort of copying in detail a pebble, a blade of grass, a hand, a profile or any other object, living or inorganic, I feel a mental ebullience coming on. Then I feel the urge to create, to let myself go, to depict the imaginary."[12]

At such moments archetypal ideas, symbols and signs emerged from Redon's unconscious, forming the basic raw material which he then subjected to further artistic treatment. It was in this secondary, conscious, aesthetic treatment of unconscious material that Redon departed from the theoretical principles later laid down by Surrealism, which, in practice, were not entirely adhered to by all Surrealist painters. Redon's detailed knowledge of biology and the principles of architecture enabled him, at this stage, to give concrete expression to his fantastic ideas in forms that correspond structurally to the laws of nature, giving them the convincing appearance of objects or beings that actually exist, and imbuing them with the breath of life. This shows how much Redon was influenced by contemporary naturalism and theories of evolution, but it is also the core of the magical and expressive quality of his art.

Another method Redon liked to use involved combining several elementary motifs according to the law of "imaginative logic" or a repetition of one and the same motif, which acquired a different significance in different contexts and in different formal permutations. A typical example of this is the metamorphosis of the eye, which can be found in many of the artist's drawings and prints, appearing in one as a symbol of the soul, while elsewhere it represents longing for infinity or the ever-present godhead. Thus in a charcoal drawing called *Eye with Poppy-Head* (1892)

15

a single realistically portrayed human eye floats before the transparent background of a window, leading us into dark, infinite space out of which some undefined embryonic forms are emerging. A similar eye is one of the main motifs in the graphic cycle called *Dreams*, which preceded it by one year. The poppy-head and "wing" attached to the eye used to be the traditional attributes in Renaissance and Mannerist allegories of Morpheus, the ancient god of dreams. This suggests that Redon meant to depict the inner eye, the eye of dreams staring into the mystery of the night. A similar significance can be given to a large number of variants of closed eyes, symbolizing an aversion to the outer world and a compensatory submersion in dreams, introspection and inner vision. In this connection one cannot help remembering the well-known group portrait of the Surrealists with their eyes closed,[13] who in this Redon-like fashion were expressing their interest in the same mental sphere.

Redon was by no means the only painter at the turn of the century who prepared the ground for Surrealism. At various stages the Surrealists acknowledged Gauguin, Filiger, Henri Rousseau, Klinger, Kubin and Munch, until they came to regard Symbolism as such as a spiritually related movement extending the Romantic tradition and predicting their own efforts to conquer the irrational. The majority of the artists, however, were in the first place painters or graphic artists. Alfred Kubin, who was essentially a draughtsman, was the only exception.

At a relatively late stage ALFRED KUBIN was assessed by the Surrealists as one of the "lighthouses" of the beginning of the century[14], even though, through his influence on Giorgio de Chirico, he has direct links with early Surrealism. The fact that acknowledgement of Kubin came so late was not due to doubts as to the value and significance of his work but arose from a lack of knowledge of the Central European culture to which he belonged. For the French-speaking countries Central Europe was — and remains — largely unknown territory. On the other hand, in his own cultural setting Kubin's work was considered rather one-sidedly simply as an important link between Symbolism and Expressionism, while his relationship to the Surrealists was until recently entirely overlooked.

Kubin anticipated Surrealism chiefly in the dream aspect of his Symbolist work. For him dreams were not only a source of inspiration but an important element in life. His neurotic disposition apparently made him especially subject to intense day and night dreaming. He succumbed to this from his youth, and in fairly frequent periods of deep depression dreams almost completely governed his personality. Kubin discussed this in his novel *Die andere Seite* (1909), which is one of the foremost works of modern dream literature.

> "Dreams overwhelmed my soul. I lost my identity in them . . . Almost every night brought me remote events and I believe that these dream images are closely related to the experiences of my ancestors; the psychic shocks they suffered perhaps became ingrained in their organisms and were thus handed down. Far deeper dream strata appeared to me in which I turned into animals, or even into a consciousness wandering among basic elements. These dreams were abysses to whose mercy I was powerlessly exposed." [15]

It is interesting that in these lines he foresaw the later Jungian concept of archetypes of the unconscious, which shows how profound his knowledge was of the laws of dream life.

Obviously the intense dream life of an artist almost completely given over to the world of fantasy must be reflected in his work. And indeed: "Night dreams, or what are called day or waking dreams, were to me for years a rich mine whose artistic treasures were awaiting their proper miner — and him I wished to be."[16]

At the beginning, in his Symbolist period — roughly the first decade of our century — Kubin derived inspiration from individual dream-images and the general irrational atmosphere engendered by dreams. Later he began to deal with dreams in a more methodical manner, studying discussions of their mechanism and symbolism in scientific publications. In the end, however, as he himself admitted, careful observation of his own dream life proved to be most fertile. He began to combine particular dream motifs into new units or depicted series of dream episodes in a single drawing. This method is exemplified in several illustrations to the novel *Die andere Seite*, the later cycle *Dreamland* (1922) and a number of individual drawings. The basic tenor of these dreams, especially at the beginning of the century, involves diverse aspects of anxiety, fear, terror and panic. A recurrent motif was that of persecution, threat and an enlargement in scale — especially of animals, whose frequent presence and superior role point to the high activation of suppressed instinctive components in Kubin's mind, which thus rise to the surface of his consciousness. One example of such early dreams, which came closest to the Surrealists' detailed records of dream images, is *The Dream of the Serpent* (*c*. 1905), a typical and recurrent dream motif. Kubin's drawing of this dream shows a hybrid female figure with a serpent's head and rearing tiger paws. This link between woman and serpent was common at the turn of the century, especially in the work of Franz von Stuck, as an allegory of sensuality, temptation and sin. In Kubin's dream the woman merges with the serpent to form one creature, which served as a symbol of the wild, cunning animal basis of womanhood and thus expressed his deep-rooted fear of sex. A very similar dream, though slightly different in meaning, can be found in the later work of the Czech Surrealist painter Jindřich Štyrský. This again confirms the undeniable connection between certain elements of Kubin's work and Surrealism.

FRANCIS PICABIA: *Guillaume Apollinaire*, 1917

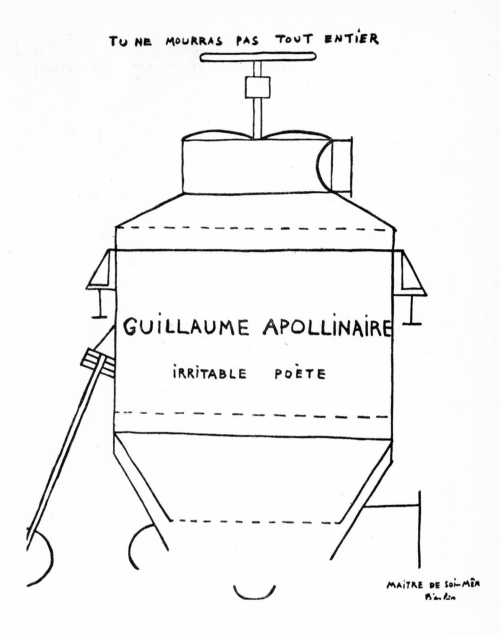

TU NE MOURRAS PAS TOUT ENTIER

GUILLAUME APOLLINAIRE

IRRITABLE POÈTE

MAITRE DE SOI-MÊM
B'orlin

THE FOUNDERS

So far we have discussed the more or less closely related precursors of Surrealism. GIORGIO DE CHIRICO must be considered a Surrealist *avant la lettre*. De Chirico did not merely deeply influence one whole branch of Surrealist painting; in the first few years he himself was considered as a member of the group, though his ideas and a large part of his work were even at that date almost diametrically opposed to Surrealism. As the years went by, when their hopes in the recovery of his original creative powers had been constantly disappointed, the Surrealists ultimately rejected de Chirico's post-war work and proclaimed that his only inspired period was the years 1912–17. This assessment basically holds true to this day, although there have been attempts to rehabilitate some of his later work in which he returned to the original sources of his inspiration. Nonetheless the scale of values which the painter set for himself in his early works was so high that he was unable to attain it a second time, though he did produce many relatively remarkable works.

De Chirico's work has its starting-point in Central European thought and art, in Schopenhauer, Nietzsche, Klinger, and Böcklin. Among the progressive currents of the Paris School he maintained a quite exceptional position, and were it not for Apollinaire's clearsightedness he would probably have remained long unnoticed. Yet at a time of bitter attacks on the external form of reality de Chirico dared speak out for the rehabilitation of the object. It was, of course, an object transformed by inner vision and for all its banality imbued with a deep hidden significance. De Chirico's maxim was revelation: a new vision of reality at special moments of rapture when the objects in the external world appear quite different, as if some strange spiritual light had imbued them with a deeper meaning and a new enigmatic life. Such moments formed the main source of inspiration for de Chirico's early work. The image that resulted from

them bore little resemblance to the reality that inspired him, for the ensuing work was reality transformed, just as some of our daily experiences are transformed in our dreams, losing their logical sequence and often even their original form. De Chirico himself said in this connection:

"When a revelation grows out of the sight of an arrangement of objects, then the work which appears in our thoughts is closely linked with the circumstance that has provoked its birth. One resembles the other, but in a very strange way, like the resemblance there is between two brothers, or rather between the image of someone we have seen in a dream and that person in reality; it is, and at the same time, it is not, that same person; it is as if there had been a slight and mysterious transfiguration of the features." [17]

The transfiguration subjecting pictorial reality to the laws of dreams is a typically Surrealist operation. Yet de Chirico's work did not always arise from a process analogous to dream activity, as this quotation suggests. Often it was directly inspired by dreams. Some of his illuminative experiences were so strong that they affected even his dreams and from there were reflected back into his pictures. This is proved by the titles of some of his works, as well as by verbal records of his dreams in which we can find certain typical motifs that appear in his pictures. For instance de Chirico's record of a dream in the first number of *La Révolution surréaliste* contains the following passage:

"I am on a square of great metaphysical beauty; it is perhaps the Piazza Cavour in Florence; it may also be one of the beautiful squares in Turin, or it may be neither the one nor the other; on one side porticos can be seen and above them apartments with closed shutters and ceremonial balconies. On the horizon appear hills with villas; above the square the sky is very clear, washed by the storm, yet one is aware that the sun is setting, for the shadows of the houses and of the occasional passers-by are very long." [18]

We seem here to be standing in front of one of de Chirico's pictures of Italian piazzas. There are other references to dreams in his writings. In the poem "On Life", for instance, we find the words: "And what is the meaning of the dream about iron artichokes?" These artichokes form an important and repetitive motif in his works. In a letter to André Breton written in 1922, in which he recapitulated his preceding work, de Chirico was still referring to dream inspiration: "This magnificent romanticism we created, my dear friend, those dreams and those visions which troubled us and which, without control, without hesitation, we threw on canvas or on paper." [19]

De Chirico's creative work cannot be reduced merely to dream inspiration. The dream images and illuminating experiences of the most varied objects, places and situations merge with childhood memories and create a special mental structure, the enigma of which is heightened in the picture with the aid of several conscious methods: the unexpected juxtaposition of objects (which the Surrealists were later to call "dépaysement"); relativity of scale; a stress on perspective and, at the same time, the systematic breakdown of its laws; the consistent use of long shadows, and so on.

We can see all these principles in de Chirico's drawings, in which he jotted down fragments of his experiences or dreams, some of which later appeared in his paintings. The transition from his Böcklin-like beginnings to his mature imaginative style must have developed in his drawings.

"Then during a trip I made to Rome in October, after having read the works of Friedrich Nietzsche, I became aware that there is a host of strange, unknown, solitary things which can be translated into painting. I meditated a long time. Then I began to have my first revelations. I drew less, I even somewhat forgot how to draw, but every time I did it was under the drive of necessity." [20]

De Chirico did indeed rapidly abandon the academic routine of drawing. The drawings from his "period of arcades" are immensely simple and have the brevity of a stenografic record of images, or the naiveté and freshness of children's drawings. In some of them de Chirico set down his experiences of a certain place in a few simple, apparently unsophisticated lines. Elsewhere the drawings are built up of more complex motifs and have a richer structure of meaning. Such a composite image can be found in a small pencil drawing, *Pleasure* (1913). Its theme is related to de Chirico's memories of his father, who plays an important part in all his early work. The father, who was a railway engineer, is represented here — as in many other drawings and pictures — by a statue of a man dressed in everyday clothes, seen from behind. The identification of this statue with his father is confirmed in de Chirico's autobiographical book *Hebdomeros* (1929): "From his window he could see the back of the statue of his father rising from a low pedestal in the centre of the square." A statue of an Italian railway engineer could indeed be seen in Turin, where de Chirico stopped on the way to Paris and whose architecture left a profound impression on him. Certain other subsidiary motifs again refer to his father: a mighty chimney linked to the statue by its shadow, symbolizing the father's virility and authority; a train in the foreground, which is a reference to his father's job, but which, in view of the disproportionately small scale, might also be de Chirico's memory of his toy trains. The painter was often to return to the kingdom of toys, as in the case of the gun at the foot of the chimney. But it is possible that the gun is an evocation of an experience de Chirico had during his stay in Rome, where, for over a century, midday was announced by the

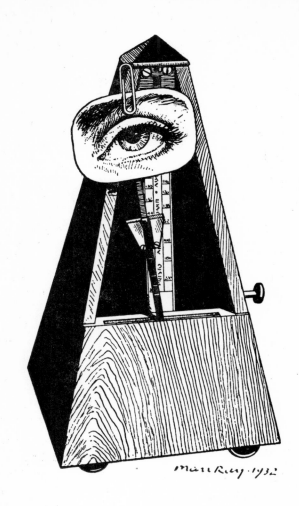

shot of an almost identical gun on the Gianicolo Hill above the city. Then there is a harbour and sailing boats, which symbolize travel and adventure. In effect, after his father's death de Chirico never stopped travelling, changing his place of abode and constantly seeking adventure, which in the end he found — to the fullest extent — in his paintings. It is therefore clear that in this apparently simple drawing there is not a single accidental motif; almost every object is of profound significance, closely linked to the artist's experiences in life. These subsidiary motifs were not consciously composed into new illogical units, but were linked unconsciously, as in dreams.

In subsequent years, in the period of mannequins and metaphysical interiors, de Chirico's drawings lost their original spontaneity. They gained in precision and exactitude, and returned to the illusive, soft shading of volume, outlined in sharp, almost geometrically rigid lines. They thus acquired the slightly impersonal character of technical drawings. This fully corresponded to his new themes of mechanical mannequins and absurd assemblages of strange objects: measuring devices, teaching aids, spherical shapes, wooden constructions and the like. The drawing ceased to be a sketch for study purposes, a hasty record of images, and became a self-contained, autonomous work.

After the First World War de Chirico remembered his academic education in Munich. As he returned to conventional subjects and classical techniques he resorted once again to the traditional free drawing which, like his paintings, reveals a sudden decline in his creative abilities.

Surrealist painting came into existence as a symbiosis of two widely differing stimuli: the work of Giorgio de Chirico, who had a direct influence on the formation of the illusionist trend in Surrealism; and Dadaism, from which it inherited, particularly in the early days, its anti-art attitude and certain non-traditional techniques such as automatic drawing, collage, or the object, whose original meaning and form the Surrealists changed and adapted to their own purposes. Several former Dadaists came very close to Surrealism (Duchamp, Picabia) or were among the leading representatives of the movement (Arp, Ernst).

In his *Artistic Genesis and Perspective of Surrealism* Breton spoke of a temporary mechanical period which directly preceded the onset of Surrealist painting. What he had in mind was the wartime and post-war work of Marcel Duchamp and Francis Picabia, whose achievements were handed on to Surrealism via the work of Max Ernst.

The mechanical period in the work of Marcel Duchamp began in 1913 with preparatory studies for his culminating work, *The Bride Stripped Bare by her Bachelors, Even* (1915–23). At that time Duchamp rejected the aesthetic

19

interests of the Paris *avant-garde* who speculated mainly on art form, and prepared his anti-art offensive which, in the end, led him to abandon art completely.

The first step along this road was the invention of "Ready-mades" and his interest in new, entirely non-artistic techniques. Duchamp said later in an interview: "I wanted to return to an absolutely dry drawing, to the creation of a dry art, and what better example of this new art than mechanical drawing? I began to appreciate the value of exactitude, of precision..."[21] His new drawings were in fact far closer to engineering blueprints than to works of art. Their strictly geometrical design was executed with the aid of compasses, rulers and protractors, dimensions were given and the individual parts were numbered and provided with the relevant footnotes. Although Duchamp really was engaged at the time in a serious study of the exact sciences, we cannot help observing the slightly mystifying character of these drawings, which ridicules contemporary attempts to create superficial pseudo-scientific analogies between Cubism and modern theories in mathematics and physics.

At the same time an entirely non-traditional symbolism and iconography came into being, for the aim of all these preparatory studies — and even of the *Large Glass*, which is a synthesis of all of them — is not a new formal structure, but the symbolic expression of the sexual act with a whole series of philosophical implications. It is remarkable that at the same time, but quite independent of Duchamp, similarly dry and objective drawings were being produced by Giorgio de Chirico. His mechanical puppets — mannequins — made up of rigid geometrical components produced another analogy in the Dadaist identification of man and machine. Marcel Duchamp gave up art even before the Surrealist group was formed. But he was to play an important part in the newly established movement: as a great example, the highest arbitrator, co-organizer and often manager of important Surrealist exhibitions.

In 1915 FRANCIS PICABIA added to Duchamp's mechanical work a series of metaphorical portraits of his friends, who were depicted as certain technical objects or devices (*Stieglitz*, *Picabia*, 1915, *Apollinaire*, *Marie Laurencin*, 1917). At the same time he drew and painted a number of absurd mechanical devices, senseless technical schemes and designs, whose individual parts were made concrete in inscriptions that were no less meaningless. All this is crowned by titles like the *Child Carburetter*, *A Little Solitude Amidst the Suns*, *Beware of Wet Paint* and so on. It can be seen that Picabia used mechanical components in a slightly different way from Duchamp. While the latter was concerned with subtle mystifications, Picabia set out to produce an obvious parody, to render art meaningless through its own media. The new mechanical morphology in the work of Picabia was expressed by means of classical techniques, in order further to stress their uselessness. Another feature Picabia shared with Duchamp's *Large Glass* was his cynical depiction of love as a mechanical act (*The Amorous Parade*, 1917) or an ironically transposed physiological process (*The Marquesas Islands*, 1917). Some of his watercolours of 1922 (*Conversation*, *Optophone*) are related to Duchamp's post-war optical experiments, this time by way of polemics, ridiculing the attempts to achieve mere retinal effects. Picabia continued his attacks on art even in the era of Surrealism (but independent of it) by the provocatively bad painting of his *Monsters* and his later *Transparencies*.

The theme of man-mechanism also appears in the Dadaist drawings of MAX ERNST, who was later to become one of the most outstanding representatives of Surrealist painting. In 1919 Ernst was working in a printing house on his de Chiricoesque lithograph cycle *Fiat Modes*. He happened to come across some big wooden letters which inspired him to strange compositions of letters, which, however, have little in common with the later Lettrism. In Ernst's drawings letters of various sizes or fragments of them were used merely as a building material for complex constructions, suppressing the semantic but stressing the formal and architectonic value of the letter. The original letters were further changed by shading and additional drawing so that they acquired the form of some non-functional tubular mechanism with vaguely anthropomorphic features. Ernst, like Picabia, identified these mechanical devices by absurd titles and inscriptions, often of an ironic-cum-erotic nature, such as his *Erectio sine qua non*. Similarly mystifying are some of his biomorphic drawings inspired by the pages of an anatomical atlas, which, in his imagination, changed into hybrid flora and fauna.

Ernst's main contribution to Surrealist drawing was the discovery of a new technique known as frottage. This conformed in all details to the theoretical principles of Surrealism as they had been elucidated shortly before. Actually, it was a new use of the old technique of rubbing used for the mechanical copying of low-relief objects such as coins, engraved architectonic signs and the like. Ernst's discovery entailed applying this technique to record visions roused by the different materials. Any child with a rich imagination possesses this ability to interpret. Max Ernst recorded one such experience from childhood: "I see before me a panel, very rudely painted with wide black lines on a red ground, representing false mahogany and calling forth associations of organic forms (menacing eye, long nose, great head of a bird with thick black hair, etc.)."[22]

Leonardo had already suggested the use of these abilities in painting in his famous thoughts on the varied pictures to be seen on crumbling walls, stones and in the clouds. Quite a number of painters followed this advice literally, as is shown by the caption for one drawing by Victor Hugo: "Drawn without light at five o'clock in the evening —

20

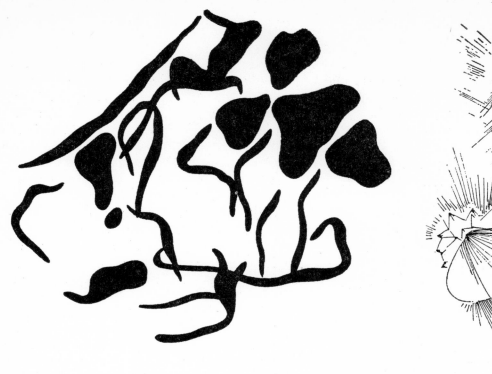

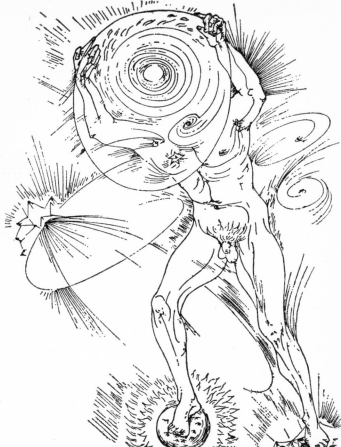

Jean Arp: *Automatic Drawing*, 1916

André Masson: *Emblematic Man IV*, 1940 ▶

what I see on the wall." Max Ernst, too, was affected by this, as is shown in his suggestive story of how he discovered frottage.

"On the tenth of August 1925, an insupportable visual obsession caused me to discover the technical means which have brought a clear realization of this lesson of Leonardo. Beginning with a memory of childhood (related above) in the course of which a panel of false mahogany, situated in front of my bed, had played the role of optical *provocateur* of a vision of half-sleep, and finding myself one rainy evening in a seaside inn, I was struck by the obsession that showed to my excited gaze the floor-boards upon which a thousand scrubbings had deepened the grooves. I decided then to investigate the symbolism of this obsession and, in order to aid my meditative and hallucinatory faculties, I made from the boards a series of drawings by placing on them, at random, sheets of paper which I undertook to rub with black lead. In gazing attentively at the drawings thus obtained, 'the dark passages and those of a gently lighted penumbra', I was surprised by the sudden intensification of my visionary capacities and by the hallucinatory succession of contradictory images superimposed, one upon the other, with the persistence and rapidity characteristic of amorous memories. My curiosity awakened and astonished, I began to experiment indifferently and to question, utilizing the same means, all sorts of materials to be found in my visual field: leaves, and their veins, the ragged edges of a bit of linen, the brush-strokes of a 'modern' painting, the unwound thread from a spool, etc. There my eyes discovered human heads, animals, a battle that ended with a kiss (*the bride of the wind*), rocks, *the sea and the rain*, earthquakes, the *sphinx in her stable*, the *little tables around the earth*, the *palette of Caesar, false positions, a shawl of frost flowers, the pampas* . . .
Under the title *Natural History* I have brought together the first results obtained by the procedure of frottage, from *The Sea and the Rain* to *Eve, the Only One Who Remains to Us*. I insist on the fact that the drawings thus obtained lost more and more, through a series of suggestions and transmutations that offered themselves spontaneously – in the manner of that which passes for hypnagogic visions – the character of the material interrogated (the wood, for example) and took on the aspect of images of an unhoped-for precision, probably of a sort which revealed the first cause of the obsession, or produced a simulacrum of that cause." [23]

Ernst's personal interpretation of frottage contains several imprecise formulations. Recently Werner Spies has tried to put these right.[24] First it should be stressed that Ernst had occasionally used the technique of frottage even before that memorable day in August 1925. It can be seen in his mechanical drawings of 1919, in which the basic

lettering elements were not achieved by transfer but by this method of rubbing. Frottage is still used here in the conventional sense of a copying technique. Its first interpretative use can be found two years later in a strange and quite isolated frottage, *Animal* (1921), where Ernst foresaw some of the possibilities that he later developed fully in his *Natural History*. The tenth of August remains the date when he fully recognized the hidden potentialities of this technique and began consistently to apply it in the sense of a fantastic interpretation of reality.

The discovery was undoubtedly aided by the publication of Breton's *First Surrealist Manifesto*, for Ernst tried to conform to these demands in his method. Therefore he laid special stress on its automatic character and suppressed his conscious share in the work process.

> "The procedure of *frottage*, resting thus upon nothing more than the intensification of the irritability of the mind's faculties by appropriate technical means, excluding all conscious mental guidance (of reason, taste, morals), reducing to the extreme the active part of that one whom we have called, up to now, the 'author' of the work, this procedure is revealed by the following to be the real equivalent of that which is already known by the term *automatic writing*. It is as a spectator that the author assists, indifferent or passionate, at the birth of his work and watches the phases of its development."[25]

In reality Ernst was no mere spectator but an active co-creator of his frottages. Psychic automatism was applied only in the phase of inspiration; while it was being executed the work was fully under the artist's conscious control. This naturally does not exclude the possibility of secondary unconscious intervention in the interpretation of inner structures. This can be shown in the increasingly complex forms and the additional introduction of spatial relations, creating on some sheets an illusion of infinite space, a typical feature of Surrealism which is achieved by the repetition of the main motif on a substantially reduced scale. But the fact remains that frottage activated the most hidden strata of Ernst's unconscious, and the direct contact with the material brought to life strange creatures slumbering in the most remote regions of his imagination. The amorphic structure of the wood was simply a stimulus which caused him to project upon it something that was hidden deep within himself. Frottage, in the work of Max Ernst, far exceeded the sphere of drawing in importance, not only because Ernst quickly began to apply this technique to his paintings as well, but mainly because it brought into being the new iconography of his subsequent fully Surrealist work. It is here that we must seek the origin of his unique bestiary of fantastic birds, wild horses and chimeras. It was here that his strange carnivorous flora grew and the compact walls of his citadels first towered up; here that his ambiguous phantom beings and his subsequent telluric and cosmogonic visions first appeared.

The thirty-four sheets of the *Natural History* (published in the year 1926 by the Galerie Jeanne Bucher) are only part of Ernst's frottage work of the preceding year. Another fifty sheets or more, which belonged to Paul Eluard, were published in their entirety for the first time in 1965 by the Spiegel Gallery. Throughout his life Ernst returned over and over again to frottage; but whole cycles came into being only in the year 1931, as illustrations to Crevel's book *Mr Knife and Miss Fork*, and in 1965 as a kind of second version of the *Natural History*, corresponding in form to his later work. In recent years Ernst has applied the technique of frottage to lithography and used it in combination with other materials. It has almost completely replaced his need to draw. We therefore find only rare examples of classical drawing techniques in his Surrealist work.

The Surrealist work of JEAN ARP also has its roots in Dadaism. In 1916 Arp was one of the legendary participants in the birth of European Dadaism in the Zurich Cabaret Voltaire. As with most of the others, his adherence to Dadaism meant a complete break with tradition. This led him to reject and even to destroy all traces of his own artistic past, linked with the Abstract Expressionist group *Der Blaue Reiter*. The rejection of conventional techniques of painting and sculpture forced Arp to seek new materials and artistic methods which would enable him to express something of the revolutionary spirit of the Dada revolt. The new morphology of his future work came into being in polychrome wooden reliefs. These already contain something of the humour that was later to become one of the constants of Surrealism. Another of these constants – objective chance – is foreseen in Arp's abstract collages made according to the "law of chance", which was one of his main stimuli.

In his third and, for us, most important field of activity Arp anticipated Surrealist graphic automatism. His few automatic drawings of the year 1916 arose without any preceding intention out of the free strokes of his brush, drawing indefinite biomorphic shapes. By contrast to Masson's later automatic drawings, in which the line is given a certain identifiable form, Arp remained in the sphere of the undefined. The apparently abstract structure of his drawings is imbued with a generous capacity for association and suggests to us images of plant, animal or human form without our being able to name any of these with certainty. Arp's elementary biomorphism, which is also found in his wooden reliefs, led to one of the main lines of Surrealist art and was to counterbalance de Chirico's objective illusionism.

Arp was not only one of the initiators of Dadaism, he was one of the first artists to acclaim Surrealism. This is shown by his participation in the first Surrealist exhibition held in the Galerie Pierre in Paris in 1925 and by his work

for the journal *La Révolution surréaliste*. While Dadaism had meant a basic break in his creation, the part he played in Surrealism can barely be detected in his work, for its main features were already contained in his Dadaist work. But a striking change did take place in 1930, when he went back to three-dimensional sculpture. The abstract, organic nature of this work enabled him to play an active part both in the Surrealist group and in the non-figurative movement *Abstraction-Création*.

The third source of Surrealist painting, apart from de Chirico and Dadaism, was Cubism. In the initial period André Breton considered it to be a bridge between imitative and non-imitative art and in *Surrealism and Painting* he even said that Surrealism must go where Picasso had gone and where he had yet to go. One of those who had followed this Cubist lesson before turning to Surrealism was ANDRÉ MASSON. His encounter with Surrealism provoked a radical break in his work and led him rapidly to abandon Cubist aesthetics. This break showed first and foremost in Masson's automatic drawings, which made him forget all problems of art form and enabled him to express all his inner, previously restrained forces in a direct, uncontrolled and non-reflective manner. He took up this new medium of expression with real passion and within a short time produced some two hundred automatic drawings. He became one of the most noteworthy representatives of the new technique, which was to play a far greater role in his work than in that of the majority of Surrealists.

In Masson's hands automatic drawing became exactly what Breton had wanted it to be – a completely obedient tool of psychic automatism, a perfect expression of the artist's "total psychophysical realm". It is not far from the truth to state that Masson, with his special psychic disposition, adopted graphic automatism as naturally as Robert Desnos assimilated verbal automatism and that their work is, in this sense, equivalent. Just as Desnos produced poetry while in a trance or in a state of hypnotic sleep, Masson began to draw in a state of Dionysian ecstasy induced by the pleasure of creation; in a giddiness that suppressed all rational control and facilitated some form of short circuit between the drawing hand and the most delicate impulses of the artist's unconscious and all his psychophysical being. With equal urgency there came into being the gestural, motoric component through which the pressure of inner energy was let off as the imaginative aspect building up the chaotic linear structure into suggestions of concrete form. The dynamic whirlpool of entangled, impulsively sketched lines is proof of the breathless speed at which these drawings were made. In their expansive labyrinthine structure they are more than a denial of all spatial orientation; even the logical cohesion of the world has been abolished.

Masson created a unified mental space of constant metamorphoses and transmutations in which the concepts of front and back, right and left, top or bottom ceased to exist, a homogeneous space of tangled elements, in which bird meets fish, woman meets star, leaf meets breast, a miraculous space in which the breast is a fish, a star, a leaf, an eye or even a flower. Masson came close to that ". . . certain point in the mind at which life and death, real and imaginary, past and future, communicable and incommunicable, high and low, cease to be perceived in terms of contradiction."[26] Breton considered the attainment of this point one of the main goals of Surrealist activity.

Masson understandably tried to transfer his new experiences to painting. He finally managed to do so in his famous series of sand pictures, in which glue, squeezed directly from the tube, gave his hand the same freedom of gesture as when he worked with a pen. He covered the resulting linear arabesques of glue with different coloured sands, which, in places, stand out in complex overlapping structures. From this period date some drawings in which automatism was replaced by boldly composed linear signs, imbued with symbolically conceived colour applied with restraint. For example, a blotch of red blood together with the beak and talon of a fowl and a real feather glued on conjure up the theme of a cockfight, which corresponds to the frequent motif of "Battles of fishes" in his paintings. Soon, in large cycles of drawings from the early thirties, these animal fights turned into murderous fights between people, with the suggestive title *Massacres*. Masson's work which lay temporarily outside the bounds of Surrealism, was dominated by themes of violence, sadism, death, human bestiality, merciless struggles for life – perhaps intense memories of wartime horrors. For a time it turned into a shocking "theatre of cruelty" rather like the one that his friend Antonin Artaud was trying to depict on the stage. In these drawings Masson's soft and flowing arabesques changed into a rhythmic pattern of short, hard, staccato lines, sharp as the knife-cuts which a bloodthirsty tangle of barbarous beings inflicts one upon the other in murderous paroxysms. In this whirlpool of destructive instincts the merciless face of Thanatos conceals the lyrical and erotic aspect of his automatic drawings, but gives him simultaneously a more profound, more tragic scale of death. For the *Massacres* are also a form of sexual struggle (murderers and victims are mostly of the opposite sex), a kind of monstrous blood orgy which even includes the theme of sacred murder and ritual sacrifice.

For a time this type of work turned Masson away from Surrealism. It inevitably brought him close to Georges Bataille and to his tragic conception of eroticism seen in the perspective of death. Collaboration with Bataille, who was at that time setting up the College of Sociology, led Masson to try a new interpretation of mythology. His fickle, unorthodox spirit was inspired even by the myths of classical antiquity, a field which was remote from

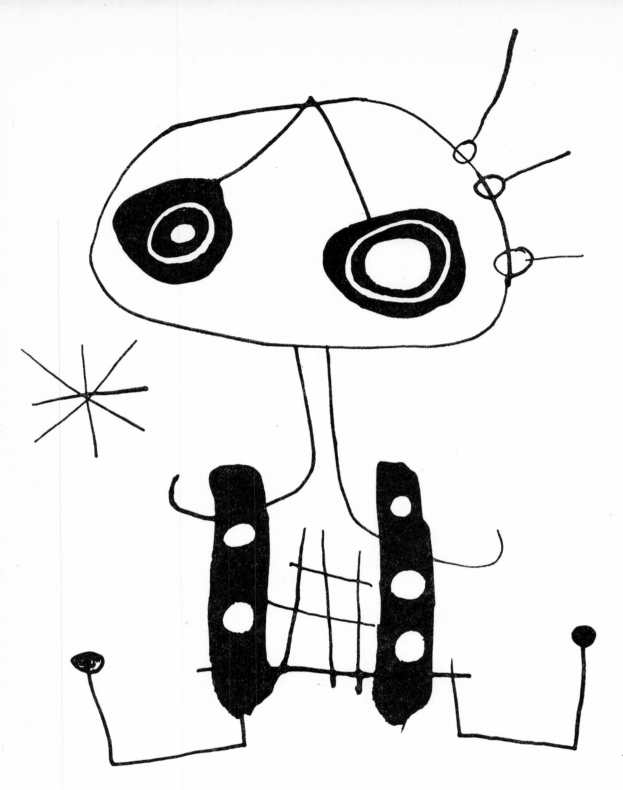

Surrealism and its endeavour to reject the cultural traditions of antiquity and establish a new myth of its own. Masson was chiefly interested in the labyrinth and connected themes – the Minotaur, Ariadne's thread and so on – reflecting the problems he experienced in his own life and work. It was in fact another, more explicit expression of what had already been contained in his previous work. During the twenties automatic drawings acted like Ariadne's thread, helping him to find his way about the labyrinth of his unconscious while his *Massacres* were, among other things, blood sacrifices to the god of Man's animal instincts – the Minotaur.

In some drawings Masson came right down to the primary cosmogonic myths. The myth of Mother–Earth was particularly close to him. He depicted this as an anthropomorphic landscape, as a Landscape-Woman, with volcanoes and hills for breast, a deep cave as the vagina in which Man is initiated into the mystery of conception, a woman whose entrails germinate the shapeless embryo of life. For Masson the landscape was not only the cradle, but also

the grave of all life. This is shown in earlier drawings dating from the time of the Spanish Civil War (1937), in which the only "vegetation" rising from the deserted and arid plains is gnawed fragments of human skeletons.

At the end of the thirties André Masson grouped his drawings into a number of cycles: *Mythology of Being* (1938), *Anatomy of My Universe* (1940), *Emblematic Man* (1940), which brought him closer to Surrealism once again. But it was only a temporary approach to Verist Surrealism. During his American exile Masson went back to the original sources of his automatism, which he now conceived on a far more abstract plane. His wartime work left a profound mark on the young American painters and formed a direct link between Surrealist graphic automatism and American Action Painting.

The second Surrealist painter with a Cubist background was JOAN MIRÓ. Whereas Masson's automatic drawings turned him into a Surrealist almost overnight, Miró's transition to the new style was far smoother and more logical. It occurred in a series of pictures dating from 1923—4 in which the new morphology and symbolism emerged stage by stage. Most of these, however, still have as their core a predetermined theme – *Ploughed Land, Hunter, Family, Motherhood* – and retained the logical correlation between individual objects or their symbols. The poetic effect of these pictures is based on a transformation of reality into fantasy, on stressed or isolated details, which are increasingly turned into abstract, autonomous, elemental symbols tied up with the given theme quite non-illusively, yet logically. It was only in his automatic drawings of 1924 that Miró reached complete freedom of expression by abandoning all rational links, logical connections and *a priori* themes. His automatism differed considerably from Masson's. It was not the result of gestural impulses but of a loose association of unconsciously motivated images placed side by side without any external links that can be understood by the reason. The morphology of these images, as we have seen, had been worked out in Miró's earlier pictures. The characteristic drawing style of his maturity acquired even greater freedom here and approached children's drawing in its simplicity. We observed a similar development in the work of de Chirico. But whereas de Chirico's drawings resembled those of children in manner only, Miró went right to the irrational sources of the child's mentality. This was fully in tune with one of the requirements of Surrealism, which endeavoured to regain entry into the lost paradise of childhood. Miró took his place in this miraculous playground in a completely natural manner. This can be seen in the playful and capricious fantasy of these drawings and the entirely natural way in which he replaced his adult perception of the world by a free imagination that is close to a child's vision. This imagination enabled him to pile up in one drawing, regardless of spatial relationship and meaning, a woman, a star, an eye, a candle and a cow, side by side with a number of other unidentifiable objects and beings, as in some children's drawings (*Pastorale*, 1924).

Apart from this new-found childhood, to which Miró owes a large part of his animal iconography, a second significant source of inspiration in his drawings was hallucination. Whenever Miró speaks or writes of his early days as a Surrealist he places special emphasis on this: "... I was drawing almost entirely from hallucinations. At the time I was living on a few dried figs a day ... Hunger was a great source of these hallucinations. I would sit for long periods looking at the bare walls of my studio trying to capture these shapes on paper or burlap."[27]

Elsewhere Miró recalls that here, too, he found the inspiration for preparatory drawings for *The Harlequin's Carnival*, one of his first and most outstanding Surrealist canvases. In this connection we should recall Breton's famous passage in the *First Surrealist Manifesto*, in which he speaks of his audio-visual hallucinations, out of which, later, verbal automatism was to grow. It, too, was stimulated by hunger. "The truth is that I did not eat every day at that period,"[28] writes Breton and refers to Hamsun's novel *Hunger*, in which the same phenomenon is to be found.

While these images were unconsciously inspired, their execution – by contrast to Masson – was entirely deliberate, with great attention being given to compositional rules of balance and the resulting artistic effect. Certain elements, in particular some abstract shapes and letters, are motivated by purely artistic considerations, by an attempt to achieve a harmonious composition in the drawing. In the process these abstract elements grew, with no conscious endeavour on Miró's part, into quite concrete signs for a woman, a star, a bird and so on. It is interesting to note that, despite the fact that they were inspired by "hunger hallucination", these drawings are not disheartening or depressing; on the contrary, they are thoroughly light-hearted and gay. Humour is an important aspect of them. It is sometimes childlike humour, naive, smiling and burlesque, at other times humour sharpened to an ingenious point of irony, or mischievously grotesque. It never turned into the black humour favoured by the Surrealists. Miró's world is not one of desperation and absurdity. It is basically a poetical *universum ludens*.

Throughout his life drawing was an important means of expression for Miró. We can trace in it the gradual shift of his vision. In the years 1925—7 it became a basic element even in his paintings. At that time he abandoned the compositional disintegration of his early Surrealist work and reached a very simple, grandiose, almost abstract form in which non-figurative, purely graphic automatism was applied to a far greater extent. His pictures of this period have as their starting-point several large blots of colour in which elementary graphic signs are inscribed with the minimum power of association but have a quite specific inner life. Breton considered these works to be

the purest expression of automatism in painting and therefore considered Miró to be the most Surrealist of all Surrealists.

In subsequent years Miró's drawing developed on parallel lines with his painting, though without influencing it greatly, as it had done in his first two Surrealist periods. In his drawings as in his paintings he achieved a new integration of the figure, stressed the biomorphic elements, and created a new organic universe of metamorphosed beings, objects and shapes. Only once more was drawing to become a harbinger of change. A series of pastels from the year 1934 depicting terribly deformed female monsters forecast the long period of "wild paintings" in which Miró reacted to the restless political situation in Europe at the time and later to the horrors of the Spanish Civil War. At that period, his vision of the world changed completely for a time. His playful universe was replaced by one of cruelty, violence, terror, and animal passions. This can also be detected in the drawings, which show greater expressiveness, monstrous distortions, appallingly grotesque images and rough, intentionally formless style, which took the place of his earlier calligraphic lines.

Miró's work calmed down at the beginning of the forties when he withdrew into the solitude of meditation and concentrated creative work. Since that time he has developed and modified the various aspects of his style with the complete sovereignty of a mature artist. Each syllable of his pictorial language is endowed with an almost absolute power of communication and syntactical flexion, which enables it to enter the endless permutations of Miró's captivating post-war work. Problems of form no longer exist. Miró has become a true creator and can give birth in as natural a manner as nature itself.

The first phase of Surrealist painting roughly covered the years 1924—7. Automatism, often of a highly abstract nature, predominated. Arp, Masson, Miró and to some extent Max Ernst (in his frottages) gave unexpected and highly varied expression to this basic principle of Surrealism. But in his *First Surrealist Manifesto* André Breton equally praised work inspired by dreams, the course of which had been indicated in de Chirico's paintings. Even though Breton's call for the exploration of the unknown territory of dreams fell upon deaf ears among the majority of Surrealist painters, de Chirico's enigmatic work found numerous followers who gained their inspiration not so much from the dream aspect as from the formal aspect of his work. In the second half of the twenties three new painters emerged: Yves Tanguy, René Magritte and Salvador Dali. In their imaginative illusionism they followed de Chirico's example and gave a new direction to Surrealist painting, a counterbalance to graphic automatism. From that time onwards Surrealism was to oscillate between these two poles.

YVES TANGUY had been prepared for his encounter with Surrealism by his friendship with Jacques Prévert and Marcel Duhamel. But the fateful impulse which decided his future course as a painter was a chance confrontation with one of de Chirico's early pictures, in 1923. This initial shock was to mature within him for some years before it brought its first admirable fruits. During that time Tanguy, who had never had any professional art training, mastered the technique of painting. He did not find his own inner world until 1927. This world was quite unlike anything that had existed in painting up to that time. He set out to make a systematic portrayal of the most varied forms of this fantastic mental landscape, which from then on, for the rest of his life, underwent only insignificant changes.

At first it looked as though his landscapes had emerged from the depths of the oceans, the depth of memories of childhood spent on the coast of Britanny, and also from the depth of the ancestral memories of his sea-faring forefathers. But soon this new-born universe cast off all ties with life on earth. Tanguy's biomorphic forms, scattered over the silence of infinite, arid planes, do not resemble any or hardly any known reality. They seem to have been made by some alien civilization that is to us completely incomprehensible. It is a universe of the mind, given concrete form in an entirely clear, illusionist manner, which gives this confusing product of the painter's imagination the semblance of tangible reality. These illusionist works perfectly satisfied Breton's conception of a picture as a "beautiful view", formulated in the introduction to *Surrealism and Painting*: "For me it is impossible to judge a picture other than as a window where I am in the first place interested in seeing what it looks out on; in other words, if there is a 'beautiful view' from where I am, there is nothing I like so much as what lies before me and dissolves into the infinite."[29]

In Tanguy's work drawing played a more subsidiary role than in that of the preceding painters. He did not use it for his preparatory material, for with the exception of some paintings from the early thirties, which he did first sketch out, he improvised his work directly in paint onto the canvas. For him drawing was an independent means of expression, a means which fitted in fully with the nature of his paintings. This is particularly true of his gouaches, which differ from his canvases only in their flat, abstract background, and even this does not apply in all cases. Among other techniques, Tanguy most often turned to pen-and-ink drawings, sometimes lightly washed in watercolour, which outlined the clear silhouette of his biomorphic objects. These are mostly situated frontally, on the first plane of the drawing and lacking all indication of depth in space, which was so essential in his paintings.

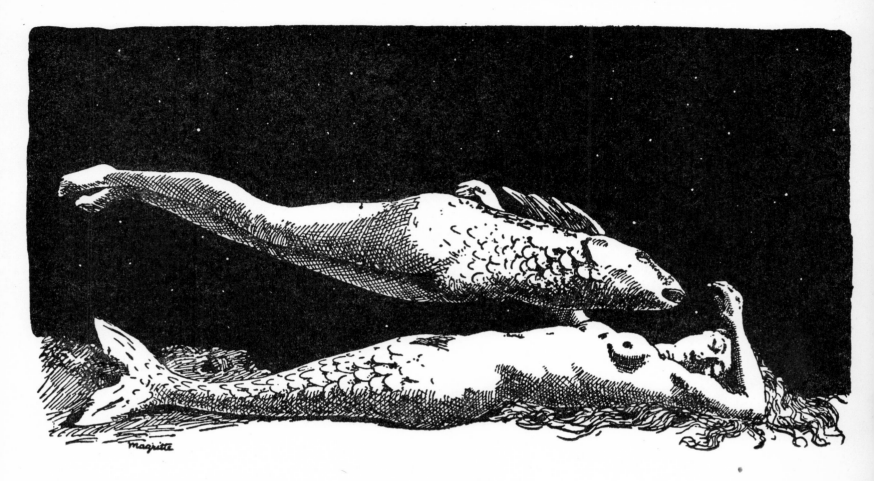

RENÉ MAGRITTE: *Androgyne's Dream*, 1938

The morphology of these drawn objects underwent slight changes as his painting developed. At first he used simple, non-identifiable shapes that seemed to germinate out of the borderland between organic and inorganic nature. In the course of time their inner structure grew in complexity until, in the end, in a sort of *horror vacui*, they filled the entire surface of the sheet in a confusion of intertwining details.

Towards the end of the artist's life, in the fifties, the basically biomorphic and sculptural concept underlying the early drawings acquired certain mechanical and, in some cases, anthropomorphic features, which were remotely reminiscent of the Dadaist identification of man with machine. This mechanical-anthropomorphic aspect is a specific element in Tanguy's late drawings and can hardly be found in his paintings.

The illusionism of RENÉ MAGRITTE, though at the outset also inspired by de Chirico, is entirely different. It has quite an exceptional position within Surrealism. His paintings departed, to a large extent, from many of the principles of Surrealist art but conformed to the spirit of Surrealism. Let us recall that in his *Second Surrealist Manifesto* Breton proclaimed as the main target of Surrealism "the provocation, from an intellectual and moral point of view, of a crisis of consciousness". This is the most profound meaning in Magritte's paintings. By contrast to many Surrealist painters he was clearly an intellectual. His work is a concentrated, conscious endeavour to break down our conventional ideas of the world, to upset the existing relations between an object and its meaning, object and word, word and image, image and reality. It is an attempt to deny all elemental evidences, to disturb our orientation in the world, to call forth a "crisis of consciousness". For that reason Magritte's works have no romantic, miraculous or fantastic element. For "what is admirable in the fantastic," said Breton, "is that the fantastic does not exist. There is only reality."[30] Magritte needed no more than bare, objectively painted reality, or else a confusing interplay of reality and its meanings to produce some extremely unsettling work. The interplay of alternations, analogies, multiplications and negations of meaning was a very bold game that was capable of upsetting the very foundations of our universe and of restoring to the world its original mystery.

Magritte was not concerned with expressing the hidden content of the unconscious, as most other Surrealists set

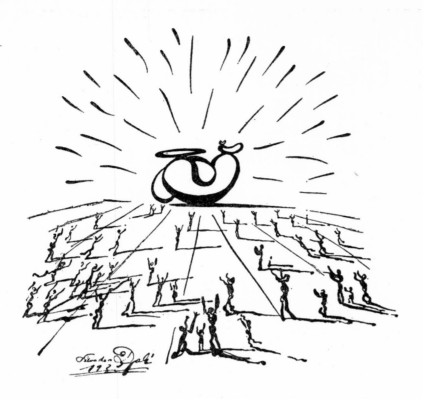

SALVADOR DALI:
The Dream of the Apparition of an Emblem, 1937

out to do. For that reason his paintings cannot be interpreted as symbolist. Nor was he concerned with expressing abstract thoughts or feelings, or illustrating a given theme. His work was neither speculative nor expressionist nor literary. It was a matter of pure imaginative thinking that cannot be transposed into words, dealing with the replacement, realignment, substitution, disconnection and reconnection of objects in the visible world, a form of thinking that was not concerned with logic, probability, or the significance of these very operations. Magritte himself defined some of the laws of his own exclusive theory in an essay entitled "The Art of Resemblance":

"The art of painting, which truly deserves to be called the 'art of resemblance' makes it possible to describe an idea capable of becoming visible only through painting. This idea comprises exclusively visible images that the world offers: persons, stars, furniture, arms, trees, mountains, solids, inscriptions, etc. On linking pictures that it sees this idea resembles an order which directly evokes mystery. The description of the idea, which resembles a world undivided from its mystery, does not tolerate fantasy or originality." [31]

What is lacking in Magritte's smoothly painted pictures in terms of originality in the method of painting is more than outweighed by the unmitigated originality of his concept. In his attempt to reconstitute the original mystery of the world Magritte made a completely new contribution to Surrealism, which has only recently been fully appreciated.

In all his work, drawing served him as an essential tool which he frequently took up. It was in drawings that the gradual changes in his imaginative thinking were taking place. It was here that he crystallized the form of his themes, which were then transferred to paintings in a more or less mechanical way. Magritte's working sketches are mostly tiny drawings in pen or pencil, often a whole series of them, depicting his "inspired visual thinking". At times this process took place in the artist's mind, but more often it did so on paper. This enabled him to gain better visual evidence of the gradual transmutations of the original idea until it reached its final compositional layout. The drawings show that Magritte's pictures came into being by a complex process of transmuting an original idea. To this he attached other themes, from the point of view of their visual, not conceptual logic. That may well be the reason why the most absurd assemblage of objects seems in Magritte's pictures to be completely inevitable and, after all, "correct".

Apart from these working sketches we have a large number of explanatory or programmed drawings whereby Magritte demonstrated the basic principles of his theory. They are as descriptive and clear as illustrations in a primer.

Most of them contain inscriptions and relate to his theory of the semantic incoherence between an object and its name. The best-known examples are illustrations to his famous text *Words and Images*, which begins with the important statement: "No object is so attached to its name that another name could not be found which suits it better."[32] By way of illustration to this statement there is a drawing of a leaf with the title *Gun*. He went on to name, always with relevant pictures, all possible paradoxical combinations deriving from this initial statement, leading up to the complete negation of all conceptual evidence of reality.

Another category of Magritte's drawings (executed in a variety of techniques) comprises variations on his main themes, often arising after an interval of more than a decade. Most of them are very carefully executed and are works of art in their own right, distinguished from the painting simply by their technique. These drawings prove that Magritte never completely abandoned any theme and that the mystery which he was trying to reconstitute was not definable with ultimate validity but remained — as always — unperceivable and inexhaustible.

Shortly before Magritte's withdrawal, after four years in France, SALVADOR DALI became a member of the Paris group. For a time Dali's versatile initiative was to overshadow all the other Surrealist painters. What he had in common with Magritte was not only his urge towards a systematic confusion of all values and "the total discrediting of the world of reality", but his use also of related techniques of painting, which intensified the new illusionist orientation of the Surrealist movement. Dali adopted this precise, highly realistic technique for a quite different purpose — for a photographically precise record of his dream, hallucinatory, unconsciously motivated images. In other words, to use Dali's own terminology, for the depiction of a world of concrete irrationality.

In a pamphlet called *The Conquest of the Irrational* (1935), writing in his typically exalted manner, Dali gives a precise definition of his intentions:

"My whole ambition in the pictorial domain is to materialize the images of concrete irrationality with the most imperialist fury of precision. In order that the world of the imagination and of concrete irrationality may be as objectively evident, of the same consistency, of the same durability, of the same persuasive, cognoscitive and communicable thickness as that of the exterior world of phenomenal reality. Important is what is to be communicated: the concrete irrational subject." [33]

The aesthetic value of the medium of this message is quite irrelevant to Dali. He considered the academic illusionism of the salon painters of the nineteenth century as best suited to his purpose, enabling him to depict all the phantasms of his imagination with great precision.

The apparently absurd grouping of incoherent objects in Dali's pictures is not an enigmatic and non-decipherable puzzle as it is in Magritte's works. It has a profound symbolic meaning and can therefore be interpreted. This hidden meaning is not obvious at first sight. While it was coming into being it was largely obscure even to the artist himself, who was but the passive recorder of ideas emerging out of the deepest strata of his being. This applies particularly in the case of Dali's first Surrealist work. Gradually, as the sources of his unconscious inspiration dried up, there began to appear consciously conceived elements and symbolic objects taken out of psycho-pathological handbooks. The paintings thus ceased to have the value of direct testimony and became merely speculatively constructed psychoanalytical "rebuses".

Nonetheless, even Dali's authentic Surrealist works remain only fascinating puzzles until we subject them to special analysis. Only then do they acquire their full meaning. The main keys to their interpretation were provided by the artist personally in his autobiography *The Secret Life of Salvador Dali* (1939), thanks to which we can now identify a whole series of apparently hermetic motifs as expressions of childhood memories, obsessions and hallucinations. Moreover, a number of existing analyses (by J. T. Soby, M. Jean, W. S. Rubin and others) have shown that Dali's work contains a number of allusions to his sexual complexes, inhibitions and perversions (fear of castration, of impotence, masturbation, voyeurism). But even the most careful analysis cannot cross the barrier of the "uninterpretable fragments" which protect his work from the danger of full verbal interpretation and give it its permanent aura of fascination.

The impenetrable nature of Dali's work and the necessity for subsequent analysis conform fully to the new programme of Surrealism. Dali's first Surrealist canvases came into being in 1929, at a time when Breton was demanding in his *Second Surrealist Manifesto* "the profound and veritable occultation of Surrealism". At the same time he placed stress on the necessity of a thorough interpretation of unconsciously acquired material. Breton's criticism of the technique of automatic writing and records of dreams stimulated Dali to proclaim that these methods had gone out of date and to replace them with new ones. One of these experimental methods systematizing Surrealist experiences was paranoiac-critical activity. Dali defined it as follows:

"The spontaneous method of irrational cognizance based on the critical and systematic objectivisation of frenzied associations and interpretations. By a purely paranoiac process it has become possible to obtain a double image, that is to say, the representation of an object which, without the least figurative or anatomic modification, becomes at the same

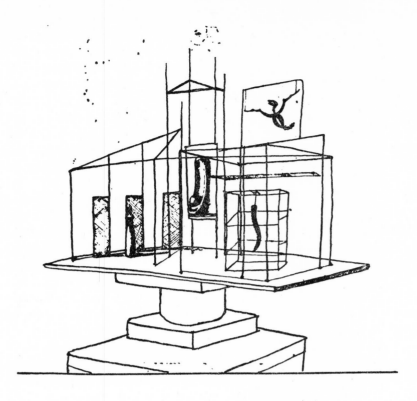

time the representation of another, absolutely different object, which is likewise free of any deformation or abnormality that might reveal that some adjustment has been made.

.... The double image (i.e. a picture of a horse that at the same time is also a woman) can be prolonged; in the continuing paranoiac process the existence of another obsessive idea is sufficient for a third image to arise (that of a lion, for instance) and so on until the concurrence of a number of images is limited solely by the paranoiac power of thinking." [34]

We can find the first implementation of this method in Dali's drawings and pictures of 1929. In the early thirties he tried to apply it generally to all Surrealist activity, but in fact it remained limited to his paintings — and not even to all of them — and to his interpretations of certain works of art of the past (such as Millet's *The Angelus*).

Dali's co-operation with Surrealism was as dazzling as it was brief and when the two partners split, both were deeply marked. The definite parting of the ways took place after growing ideological disputes in 1936, even though Dali continued for some years to develop the basic principles of his Surrealist work and until the beginning of the war participated in all larger Surrealist exhibitions.

Dali is one of the few painters who "did not forget" how to draw after their conversion to Surrealism. The academic routine of drawing, which he had brilliantly mastered in his youth, suited him ideally; after a brief period of isolated experiments with form he used it for the careful record of the world of concrete irrationality. His initial lack of interest in problems of artistic form, which can be seen in his paintings in the adoption of impersonal illusionistic technique and the attempt to suppress all the marks of the brushwork, led him to a clear eclecticism in the sphere of drawing. In the course of the thirties his work reveals a series of different styles in drawing, often used side by side. It is never a spontaneous gestural psychogram, directly depicting the faintest vibrations of the artist's sensibility. Dali's drawing is, at the core, non-expressive and descriptive. For the first record of his dream and paranoiac images he mostly used objective drawing, at times detailed, at others sketchy, often with notes added. In some drawings we can find a wavy Art Nouveau arabesque, which reflects his admiration for the style.

Elsewhere there are variations of Bracelli's composite figures, reflecting his interest in Mannerism, which intensified as the years went by. Mannerist elegance and sophistication is characteristic of most of his free drawings and erotic sketches. In the middle thirties Dali's drawing style became looser, his line acquired greater suppleness, flexibility and suggestiveness, becoming evocative rather than descriptive. After parting company with Surrealism Dali slowly returned to a sterile Ingres-type classicism. Later, under the influence of Tachism, there began to appear in his work gestural records relying on the autonomous expressiveness of blots of colour and impulsively drawn lines.

Surrealism was not only a crossroads for individual poetic discoveries. A serious attempt was also made to find the sources of collective invention. The history of Surrealism is woven through with constantly repeated attempts to merge two or more creative individuals in one and the same work. This concept leads from the pre-Surrealist *Magnetic Fields* (Breton and Soupault) via the *Immaculate Conception* (Breton and Eluard) to the joint post-war paintings of Matta and Brauner.

The most popular medium for seeking common sources of imagination were various Surrealist games. Among these the Exquisite Corpse concerns the arts most directly. Its original verbal form arose at the beginning of the movement with the joint participation of poets and painters. It was based on the principle of chance in constructing sentences made up of several words or phrases, each written independently by a different person. The resulting product was often full of surprisingly poetical turns, such as the sentence, "The exquisite corpse will drink new wine", from which the game's name is derived.

The same principle was later applied to drawing. It consisted of a form of "Consequences" in which three or four people drew on a horizontally folded piece of paper, each adding a single part of the human figure without knowing what the previous person had drawn. The human figure was often only a vertically composed scheme. The resulting hybrid monsters sometimes recalled the human anatomy only remotely. Such works of collective invention, which in Breton's view "set free the metaphoric activity of the spirit", were in most cases of very questionable value. In spite of their great popularity they remained no more than entertainment and can barely be regarded as a medium for exploring the human spirit. More interesting results were produced by poets, because when a painter participated, every stroke of the pencil revealed his characteristic style and anonymity was lost, thereby lessening the attraction of the game. The Surrealists saw in the game an application of Lautréamont's maxim that poetry will be produced by all, not by one alone.

THE EXPANSION AND OCCULTATION OF SURREALISM

About the year 1930 Surrealism was finally accepted as the leading trend of the interwar avant-garde. Its distinct ideology, its left-wing political orientation, the originality and novelty of its artistic concepts and its stimulating atmosphere made it the centre of gravity towards which a large number of young progressive artists were gradually attracted, not to mention those whose work clearly fell within the sphere of its influence without their being formally bound to the movement. At this time Surrealism became really international, and independent national groups were set up that maintained only loose links with the centre in Paris.

How suggestive and stimulating the influence of Surrealism on contemporary art was can be shown by the fact that one of the greatest painters in the first half of the century — PABLO PICASSO — himself succumbed to its influence in much of his work. In the initial stage André Breton repeatedly stressed how much the movement owed to Picasso's example, but not much time was to pass before the relationship became inverted. From 1925 on Picasso drew new stimulus from Surrealism for his protean work. His work, aiming at the active metamorphosis of reality, was, in substance, a negation of the Surrealist techniques of psychic automatism and inner vision. But in spite of this, it assimilated a whole series of morphological and iconographic stimuli from the works of individual Surrealist painters and imbibed the overall irrational atmosphere of the movement. This can be seen in his pictures, his sculptures, his poems and objects and also in his drawings.

The first signs of this influence can be found soon after 1925, when Picasso's works suddenly awakened to an intense inner life, with the expression of free instincts and passions, reflected in convulsive outlines of dramatically distorted figures. Close to Surrealism are the phantasmal beach scenes executed at Dinard (1928), where he also drew the sketches for the enormous biomorphic monuments which were to line the French Riviera coast. Picasso returned to the bizarre metamorphoses of the human figure in studies for the *Crucifixion* (1932) and the cycle of drawings *Anatomy* (1933), which is a kind of pattern-book of very remarkable Surrealist sculptures, though these were never executed.

Picasso came closest to Surrealism in a series of drawings executed in 1933, depicting mostly fantastic figure-objects on the seashore. These monstrous assemblages, where parts of the human anatomy are linked quite haphazardly with isolated pieces of furniture, reveal the influence of the Surrealist object and its bizarre fantasy. The mysterious and hallucinatory atmosphere of Surrealist works is also reflected in preparatory drawings for *Minotauromachy* (1934–5), relating to the only classical myth which passed muster with the Surrealists. Points of contact with Surrealism can be found in other works by Picasso, but they remained only a minor aspect of his very varied output, which basically tended in a different direction.

By the early thirties the new territory which Surrealism had discovered had definitely been conquered. Its position on the map of the mind had been stipulated, and its scope, language, laws, bizarre inhabitants and miraculous fauna and flora were roughly known. The second generation of Surrealist painters was given the task of settling this territory, getting to know its dialects, myths, rituals and mores, exploring its as yet uncharted borderlands. The new explorers faced a more modest task and did not win the glory of the conquerors. But their mission was no less important, because without them we would possess only very vague outlines of this new domain of the mind.

The esoteric work of VICTOR BRAUNER, who became a member of the Paris group in 1933, was in full accord with the new requirements of the profound occultation of Surrealism. In his work, which was often inspired by the occult doctrines that Breton referred to in his *Second Surrealist Manifesto*, he set out to explore and express the mythical and magic aspects of the human spirit. For Victor Brauner, drawing was a kind of pictorial diary in which, with complete regularity, he recorded all the phantasmal images of his inner world. It thus became a true mirror of the changes his artistic universe underwent. In his somewhat uneven work of the thirties we can most often find infinite metamorphoses of human figures, which in turn assumed plant, animal or mechanical forms. In 1938 Victor Brauner lost an eye during an incident in a studio, which, quite unaccountably, he had foreseen in a number of his earlier drawings and pictures. From that moment on, his work turned inwards. He began to concentrate on the depiction of "psychological spaces" inhabited by almost immaterial beings, chimeras and phantasms, from which emanates the spiritual light of intense contemplation.

In 1941 a remarkable sketchbook came into being, recording in dozens of drawings the birth and transformations of a new mythological being called Conglomeros. In it Victor Brauner turned anew to his favourite theme of metamorphoses, which he now conceived as a symbolic visualization of certain aspects of man's inner life. The dark forces of our unconscious were given concrete shape in dual faces (inner and outer, diurnal and nocturnal), multiple bodies, the constant merging of man and animal: a cat, a serpent, a tiger, a horse, as metaphorical expressions of instincts and passions. In the following years Victor Brauner stressed the esoteric aspect of his work in hieratic compositions whose atmosphere is remotely reminiscent of Egyptian mysteries. In 1949, at the point when he began to work out his victorious mythology of being, he parted company with Surrealism.

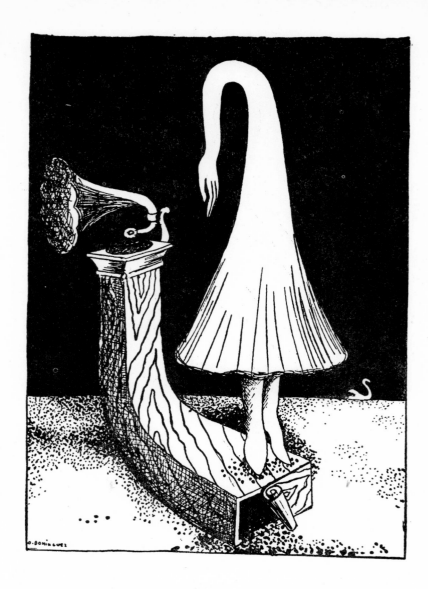

OSCAR DOMINGUEZ:
The Memory of the Future, 1938

PAUL DELVAUX never became an official member of the Belgian or Paris group, but his work has close links with Surrealism. It is related to it by its illusionism in which we can detect traces of the influence of de Chirico and Magritte, and by Delvaux's original and highly personal poetic vision concentrated on one theme, the mythology of Womanhood. "The problem of Woman is all that is most marvellous and most disquieting in the world," wrote André Breton in his *Second Surrealist Manifesto*. Delvaux's entire work is a convincing artistic interpretation and confirmation of this statement. Delvaux's dream world emerged unexpectedly in several drawings and paintings dating from 1936. In the course of his life it underwent only slight changes. To be precise, this dream world appeared in drawings, which served him for the first recording of images and for the gradual elaboration of their final compositional layout.

Delvaux's beautiful, nude, sensual yet inaccessible women are not of this world. They are beings that appear to us in dreams in squares of unreal, deserted towns, in dark alleyways, station waiting-rooms or in the company of dressed, indifferent males. The clear dream atmosphere of these works might lead to the assumption that they are records of Delvaux's night dreams. In fact, they are an infinite variation on one single day dream of Delvaux's childhood, a dream reflecting unsatisfied pubertal desires. All these women are the subconscious incarnation of the painter's mother. That is why they are so seductive and yet inaccessible, why they are condemned to eternal expectation and untouchability, and why the men who meet them at every turn do not even see them. The only one who "sees" Delvaux's woman, who looks at her with fascination, is a young boy in the picture *Visit* (1939) — the painter himself.

While Delvaux was a painter of sublimated eroticism, HANS BELLMER was the true heir of de Sade's universe of the most intricate bodily pleasures. Bellmer came into contact with Surrealism in 1934, when the journal *Minotaure* published photographs of his *Doll (Poupée)*, a flexible perverse object, a harbinger of the gallery of mannequins at the International Exhibition of Surrealism in 1938. Although Bellmer returned to objects several times, the core of his work is drawing and graphic art. His first Surrealist drawings are somewhat heterogeneous in style and some

of them clearly reveal the influence of Alfred Kubin, but their intensely erotic mood is already typically Bellmer's own. In the course of a few years he worked out an elegant, precise and highly ingenious style of his own. From that moment on — as in the case of Tanguy and Delvaux — his inner vision took precedence over all aesthetic interests, giving final shape to his artistic world. From the early forties on, regardless of period changes in style, it hardly changed at all.

The geneaology of Bellmer's subversive eroticism leads in direct line from de Sade to Bataille, whose work he illustrated several times. Like de Sade's work, Bellmer's drawings include an exhaustive list of sexual perversions, whose liberating and subversive value in the life of the repressive society of the age has recently been convincingly shown by Herbert Marcuse. And as with Bataille, Bellmer's eroticism was closely bound up with cruelty and the death instinct, as shown by the morbid disintegration and transparency of bodies, mercilessly revealing their inner organs, embryos or the naked skeletons of copulating couples. The main erotic intensity in Bellmer's drawings is not, however, focused on the subject as such, but on the fluid, sensitive and sensual line, which manages to endow even purely biomorphic compositions with the same erotic potential as the most descriptive depiction of the sexual act. Moreover the difference between these two poles of his work is so slight that they often merge organically in one and the same drawing. Bellmer managed to create a completely homogeneous physiological universe in which we find a complete merging of what is within and without as well as multiplications and transformations of individual human organs such as vagina/ eye, leg/nose, buttocks /breasts. We find completely free anatomical mutations of the human body, every part of which is charged with an inexhaustible libidinous energy. Bellmer's work thus became the most effective tool of the Surrealist demystification of sex and at the same time of its concept of raising eroticism to one of the highest values in life.

In his essay "Recent Trends in Surrealist Painting" (1939) Breton announced a new return to automatism, this time devoid of the last remnants of control by the reason or by will-power. The tools of this new "absolute automatism" were to be Dominguez's decalcomania and Paalen's fumage.

OSCAR DOMINGUEZ became a member of the Paris group in the year 1934. His recommendation was his pictures, which he had brought with him from his native Tenerife. His talent was marked by fertile invention rather than clear imagination, which is shown by his considerable and remarkable creation of objects, from which he often derived

subjects for his drawings and pictures (*The Memory of the Future*, 1938). In 1936 Dominguez discovered what is known as decalcomania, which Breton, who was more enthusiastic about the new technique than it truly deserved, defined as follows:

"To be able to open your window at will on the most beautiful landscapes in the world and elsewhere, use a broad brush to apply black gouache – more or less diluted – to a sheet of glossy white paper. Cover it immediately with a similar sheet on which you exert average pressure with the back of your hand. Then slowly lift the upper edge of this second sheet ... what you have before you is possibly da Vinci's old paranoiac wall, but it is a wall carried out to perfection."[35]

It is clear that not even the technique was entirely new. As in the case of frottage, it was a popular children's game. It had already been applied to art by Victor Hugo. What was new was the substitution of gouache for ink, which provided richer effects, and its systematic interpretative use. By itself decalcomania is a mechanical process based exclusively on the principle of chance, and thus within easy reach of all and sundry. For that reason it gained much popularity among the Surrealists and was practised, like the "Exquisite Corpse" by both painters and poets.

The only automatic aspect was the process of interpretation. It derived from the broad scope for association offered by its amorphic structure, which was vaguely reminiscent of a submarine, a lake or a cave landscape as well as a thousand other things whose very existence was due to the degree of excitement achieved by the spectator's imagination. Decalcomania inspired Benjamin Péret to write a story and the Czech poet Vítězslav Nezval to produce a whole collection of poems.

Nonetheless, the somewhat monotonous aspect of the mechanically acquired decalcomania structure soon cooled off the initial interest that the Surrealists had shown in it. Dominguez, aided by Marcel Jean, vainly tried to keep it alive by a new series of consciously guided decalcomania formed into more or less concrete images. Decalcomania would clearly have remained no more than an ephemeral interlude in Surrealist activity, had not Max Ernst given it full value in a series of wartime pictures. Later Hans Bellmer did the same in some of his gouache drawings.

The second new technique was fumage. Breton considered it at the time to be the beginning of a new era of absolute Surrealism. But it proved to be even more questionable than decalcomania. Its use was virtually limited to the work of its discoverer, the Austrian painter WOLFGANG PAALEN. He joined the Surrealist movement in the mid-thirties, when his drawings of imaginary totemic landscapes assumed the appearance of vertiginous space built up from some kind of peculiar vegetative architecture. The discovery of fumage was stimulated, to some extent, by Paalen's admiration for Georg Christoph Lichtenberg, the author of meditations written "in the company of burning candle". (Paalen translated some of his work, thus making it accessible to the Surrealists.) The principle of a fumage is a technique of drawing on white paper or on freshly primed canvas with smoke from a lighted candle. The result is a confused smoke structure which can be interpreted in a similar manner to decalcomania. By contrast, the use of fumage was far more limited. The only direct heir is perhaps Yves Klein's technique of flame-painting. Paalen himself went back to automatism in a number of calligraphic, gestural drawings made in the early fifties. They played an important part in the process of bringing Surrealism closer to certain forms of Lyrical Abstraction.

In the thirties the Surrealist activity was enriched by the work of numerous painters of varied quality, whose drawings are little known or never reached the level of the artists we have discussed.

One of these was the romantically inclined VALENTINE HUGO, whose pleasing, decorative work includes illustrations, portraits of her Surrealist friends and a few lyrical transpositions of dreams.

Of far greater value is the work of the German artist RICHARD OELZE. In the mid-thirties Oelze attracted the Surrealists by his drawings and paintings of phantom-like creatures and strange, zoomorphic landscapes in which he gave expression to his own imaginative world. As the years passed, this multiplied in its form, but its substance remained unchanged to this day. The substance is a highly flexible protoplasmatic matter radiating a mysterious light fluid — universal matter — out of which are woven the spectral forms of his fantastic landscapes, tossed in an inner whirlpool, and his disquieting, anxious beings. Oelze's immensely delicate pencil drawings have the same qualities as the areas of colour in his paintings.

The Swiss painter KURT SELIGMANN contributed to Surrealism some of the heritage of fantastic medieval magic and heraldic art. His drawings follow on in a direct line from the sharp and cruel German graphism of Urs Graf and the frenzied atmosphere of Hans Baldung Grien's sabbaths. At the end of the Second World War Seligmann's increasing interest in problems related to medieval magic took him away from active participation in the Surrealist movement.

In the second half of the thirties the Romanian painter JACQUES HÉROLD evolved his mineralogical style, whose crystallographic structure in many ways recalls the crystalline skeletons of Masson's drawings of the same period.

The drawings of MAURICE HENRY belong almost exclusively to the sphere of black humour and purely visual absurdity.

CZECH SURREALISM

Originally Surrealism grew out of the spiritual atmosphere of the post-war avant-garde in Paris, but gradually it began to assume a more international character. The overwhelming majority of painters who became members of the Paris group in the thirties were foreigners. Furthermore, several national groups came into existence. They developed on parallel lines but remained independent in their activity and never lost touch with their local cultural environment.

One of the most active groups existed in Prague. By contrast to others, painters here held a dominant position. The Surrealist group in Czechoslovakia was founded in the year 1934, but long before that date some artists had moved closer to Surrealism. This is particularly true of the avant-garde *Devětsil* group, which in the twenties represented the most progressive trends in Czech art.

Their programme had been worked out by Karel Teige, who later became the chief spokesman for the Surrealists. It was based on the polarity of Constructivism and Poetism. The former was mainly applied to architecture, the latter to poetry and painting. A close comparison reveals a series of points of contact between Poetism and Surrealism. Their development went along parallel lines and began to converge strikingly in the early thirties. This *rapprochement* found expression in a big exhibition called "Poetry 1932", held in Prague jointly by Surrealist painters and sculptors

and the *Devětsil* group. Side by side with works by Jean Arp, Salvador Dali, Max Ernst, Giacometti, Masson, Miró and Tanguy hung canvases by Jindřich Štyrský, Toyen, Josef Šíma, František Muzika, František Janoušek, Alois Wachsman and others. The work of some of the Czech participants could even be qualified as Surrealist, particularly that of Jindřich Štyrský and Toyen, who were beginning to give more concrete form to the evocative, semi-abstract structures of their former "artificial" canvases by transforming them into phantom-like objects and phantasmic landscapes.

Jindřich Štyrský devoted himself — more systematically than any other Surrealist painter — to exploring the problem of dreams and a considerable part of his work is directly inspired by night dreams. Shortly before his death in 1942 Štyrský summed up all his dream-based work in a book entitled *Dreams*, which was not published in Prague until 1970. Štyrský began keeping written records of his dreams in the mid-twenties, roughly at the same time as the Surrealists. His first drawn records of dream objects date from the end of the twenties. Later on, he tried to interpret them in his paintings. In substance Štyrský's attitude to dreams was identical to that of the Surrealists. It led from simple record to interpretation and the resulting overlapping of dreams and waking life. But, by contrast to other Surrealist painters, of whom in most cases we know only the final achievement, Štyrský gave us an insight into the entire process of dream inspiration.

Most of his written records link up with a cycle of sketches, coloured drawings, collages and paintings, in which the original dream motif was gradually transformed. For him the dream was never a mere store of ready-made images needing only to be copied. His attitude to dreams was not illusive but selective and analytical. Štyrský always took a key-point in the dream, a typical detail, most often a symbolical object round which the main action of the dream and its atmosphere were centred. A dream object of this kind depicted in the immediate pictorial record was usually modified and interpreted in a whole series of works. More important than the visual image of the object itself is its meaning, often a fetishistic one, connected with early erotic experiences in childhood and adolescence. In Štyrský's drawings and paintings — like those of Salvador Dali — this return in dreams to the lost paradise of childhood is a frequent theme. Štyrský concentrated almost exclusively on dream objects. Mere chance does not come into it. It corresponds to all his Surrealist work in which painted or collage objects held a dominant position. By the side of dream-inspired work Štyrský used other levels of expression, mostly leading to the erotic sphere, or to aggressive and critical imagination and black humour.

By contrast to Štyrský's, TOYEN's work is sovereignly enigmatic and to this day the painter is careful to hide all the keys to its secrets under a cloak of reticence. This consistent occultation of all sources of her inspiration complicates the interpretation of her drawings and paintings but gives them a disquieting enchantment and the

JOSEF ŠÍMA: *Old Tree, c.* 1927

TOYEN: *The Remains of the Dreams*, 1966

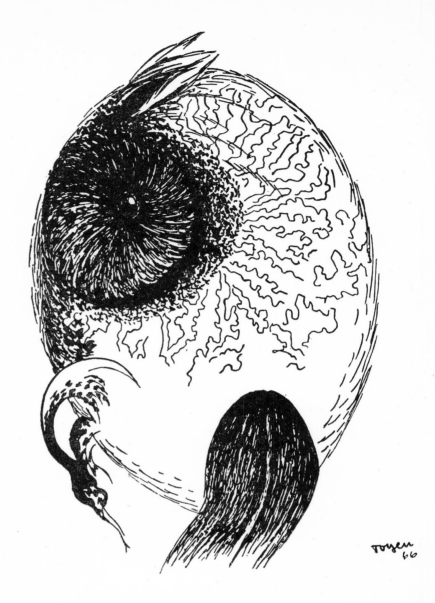

magic attraction of an enigmatic oracle, an impenetrable message. Toyen is one of those painters in whose work drawing acted as an important catalyst of artistic transmutations. Indeed it formed a constituent part of her work. She brought to Surrealism the immensely fine and sensitive line of the evocative compositions of her earlier "artificial" period in the twenties, in which she was already anticipating certain aspects of Lyrical Abstraction. This line began to take on more concrete form in undefinable phantom-like shapes of great suggestive power, which in the cycle of drawings called *Spectres of the Desert* (1937) changed into cracked and petrified animals, birds and nests placed in an infinite arid space. This silent and petrified world of quiet horrors appeared similarly in the cycle *The Shoot* (1939–40), which was executed in the impersonal verist technique of magic realism. These shocking drawings are parables of the cruelty and bestiality of the Second World War, projected into the innocent world of children's games, mutilated toys, dead birds and deserted broken objects. The theme of destruction and death became even more intensified in another wartime cycle *Hide, War* (1944), an apocalyptic vision of the end of the world inhabited only by phantasmic skeletons of animals, stumps of trees and empty cages. After the war Toyen moved to Paris and became a member of Breton's Surrealist group. She retained her membership until the group broke up. In the cycle *Neither Wing nor Stone: Wings and Stones* (1949) the illusionistic technique of her wartime work changed to the minute realistic depiction of fragments of objects scattered on the surface of the sheet of paper in completely illogical and confusing patterns. In the fifties Toyen's drawings became suggestive again, enabling her to express the phantasmic variety of meanings inherent in her increasingly libidinous images.

Surrealism sank deep roots in Czechoslovakia and influenced the work of at least two generations of artists. In the thirties there were, beside Štyrský and Toyen, a number of other painters, one-time participants of the "Poetry 1932" exhibition, who, though not actually members of the Prague Surrealist group, came very close to Surrealism or expressed it fully in their work.

One of these artists was FRANTIŠEK MUZIKA in whose drawings and paintings, from the mid-thirties on, there began

to appear lyrical configurations of metamorphosed beings and objects set in illogical contexts on a Chiricoesque stage of vanishing points. Later these isolated objects were linked into composite unified shapes, mysterious dream objects, endowed with a quite exceptional poetical potential. At the same time Muzika's work embraces the principle of the anthropomorphization of dead nature with dream forms of women's faces and bodies projected into splitting boulders. His post-war drawings are filled with fantastically transmuted forms of the organic microcosm, tree-shaped cell structures, totems, tumuli or extinct citadels, the archetypal residues of cult and mythical images.

The second painter to identify himself with Surrealism towards the end of his life was FRANTIŠEK JANOUŠEK. He, too, belonged to the broader circle of Czech imaginative painting. By contrast to Muzika's almost classical restraint and contemplative, poetic quality, Janoušek was a painter of explosive imagination, whose target was cruelty, disintegration and violence. This side of Janoušek's work came to the fore only under the pressure of events in the mid-thirties. His earlier work, pictures of Arcadian, embryonic landscapes with a dominant atmosphere of calm, pleasure and joy were inspired by Miró. The first indications of the forthcoming metamorphosis, which resulted in his catastrophic vision of the world, appeared in a large series of pastels, executed between 1935 and 1937. For Janoušek drawing became a screen on to which to project his obsessions and traumas, a mirror reflecting the convulsions and anxieties of the period. He expressed these feelings in the form of mutilated, gagged figures suffering from malignant growths, covered with bloodstains, wounds and monstrous tumours, the figures of tortured anonymous victims, foreshadowing the massacres of the Second World War.

Other painters of this generation came close to Surrealism at least in certain aspects of their work, while for others still it served as a starting-point for work leading in a different direction. The most outstanding of these artists was JOSEF ŠÍMA, a member of the Paris group *Le Grand Jeu*. His distinct imagination showed certain features related to Surrealism even in the second half of the twenties, though he never depended on it in any way.

The direct influence of Surrealism, on the other hand, can be seen in the work of ALOIS WACHSMAN, who aimed at the myth of childhood memories and used to the full the principle of chance encounters not only of objects, but even of events unrelated in time.

The work of FRANTIŠEK HUDEČEK, FRANTIŠEK GROSS and ENDRE NEMES again derived from Surrealism. Nemes moved his Chiricoesque mannequins from Italian squares to the mysterious setting of the old quarters of Prague. For him Surrealism was a starting-point for some remarkable work executed in Sweden since the end of the Second World War.

Surrealism also left its mark on the following generation, particularly on the artists of the Ra group. At the end of the forties some of them (Istler, Tikal) joined the Prague Surrealists, who had been re-established as a group by Karel Teige.

The drawings of VÁCLAV TIKAL were originally influenced by de Chirico and Dali. The artist then abandoned these patterns and his works came to contain two different but basically complementary aspects. One of them shows a complex world of meaningless mechanisms and imaginary apparatuses symbolizing the dominance of a technically overdeveloped civilization over the last remnants of human nature. Quite apart from this there exists an original world of fantastic vegetation untouched by civilization. In some cases the artist was highly stimulated by the technique of frottage.

The drawings and paintings of JOSEF ISTLER waver between graphic automatism with its abstract colour structures and evocative images of unreal objects and figures. In about 1950 they acquired the form of hallucinatorily exact, phantom-like beings, growing out of sand dunes and plains.

The post-war Teige's group also left its mark on the work of Mikuláš Medek. At the beginning he concentrated on themes of cruelty, threat and attack expressed in the unusually suggestive media of Verist Surrealism. Later he moved on to the existential symbolism of fateful events, presenting apparently simple, everyday actions as rituals.

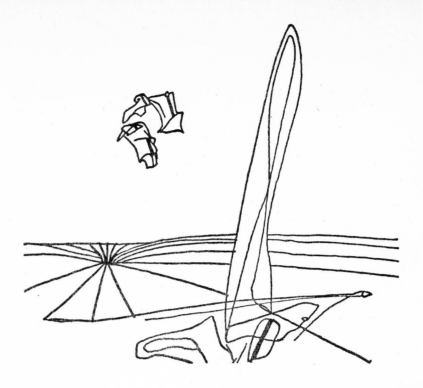

MATTA: *Drawing*, 1943

SURREALISM IN EXILE

The outbreak of the Second World War completely upset the collective activity of the Paris group, which had long been involved in an uncompromising struggle against Fascism. Once France was occupied this prevented the members from taking any public action. Some Surrealists went underground; others hid in the French countryside. Many of them, particularly painters, emigrated to the United States and to Mexico (Breton, Duchamp, Ernst, Masson, Dali, Tanguy, Paalen, Man Ray, Seligmann). During the war New York became the home of organized Surrealist activity, which left its mark on young American painting. Several other personalities joined the group and their work left a decisive stamp on Surrealist painting in the forties.

The most important of these newcomers is, undoubtedly, ROBERTO SEBASTIAN MATTA ECHAURREN, a Chilean architect who joined the Surrealists in 1938 but whose painting reached maturity only in the early forties. When Breton spoke about the return to absolute automatism in his *Recent Trends in Surrealist Painting*, he was thinking not only of Dominguez's decalcomania and Paalen's fumages, but also of Matta's early drawings and paintings, which fully bear out this opinion.

Matta's *Psychological Morphologies*, also called *Inscapes*, are dynamic gestural records of inner landscapes, created out of spontaneously drawn linear clusters floating in an undefinable abstract space. In the course of time Matta's chaotic linear structure became clearer and more simple; his amorphous ravels were replaced by curves, straight lines and spherical surfaces in an attempt to evoke cosmic space, into which the artist projected the gestural diagrams of his psychic microcosm. Towards the end of the war Matta's drawings began to include suggestions of anthropo-morphic shapes, out of which grew elongated, hieratically gesticulating beings, priests of some future cybernetic religion. In this way Matta wished to express the hidden forces that are trying to control our lives. These threatening, half-mechanical creatures inhabitated the imaginary spaces of his drawings and paintings for many years. The drama they enacted is not only the inner drama of human existence, as was the case when the artist began work. What they represent now is the fateful drama of the world into which Matta feels drawn with increasing urgency.

Another newcomer during the Surrealists' period of wartime exile was the Cuban painter WILFREDO LAM, who brought to Surrealism a direct expression of primitive rituals and myths. He had some African Negro blood and was the only one of the Surrealist painters to resurrect in his work the heritage of primitive cultures, which up to that time had merely been platonically admired. At the beginning of the century Picasso had derived inspiration from the formal features of Negro sculpture. Lam penetrated to the live core of the primitive, magic mentality which lies dormant in the depths of the consciousness of each one of us. His drawings brought into being a new mythological world of primitive deities, idols, totemic animals and strange composite beings, expressing the instinctive, myth-creating

40

forces of his mind. Such work was not inspired by ethnography, but by the rediscovery of the archetypal sources of imagination, which gave birth to the authentic deities of primitive cultures. The very existence of these creatures proves that the Surrealist attempt to create a new myth did not remain simply wishful thinking. In fact Lam's jungle deities are of the same lineage, even if they serve a far wilder cult, as the ingenious cybernetic demons in Matta's pictures. His imaginative world went through several stylistic changes in his drawings, but its substance has remained unchanged to this day.

The third great personality to appear at the end of the war was an American of Armenian origin, ARSHILE GORKY. His work shows most clearly the decisive influence that Surrealism had on many painters (Pollock, Rothko, Still, Motherwell, Baziotes and others) who after the war became the founders of the new American school of painting.

For almost fifteen years Arshile Gorky followed in the footsteps of Pablo Picasso with the patience of a cultivated follower who lacks any invention of his own. This dependence was broken down by the Surrealists. First Miró's, then Masson's and Matta's works served Gorky as an example, helping him to discover the hidden sources of his own imagination. The change occurred in about the year 1944, when he produced his first, already quite authentic, automatic drawings, using a loose, flowing line which soon began to appear in his abstract paintings as well. Miró's biomorphism was soon replaced by a rapidly sketched, gestural arabesque. Within the span of one year this became fixed in a new, lyrically designed compilation of forms that was characteristic of his mature style. But before he could fully develop this, an unexpected series of personal catastrophes led to his tragic death in 1948. In the short period of his authentic artistic activity Arshile Gorky managed to produce work that became an important link between Surrealism and American Action Painting.

WILFREDO LAM: *Drawing,* 1954

ARSHILE GORKY: *Drawing,* 1945—6

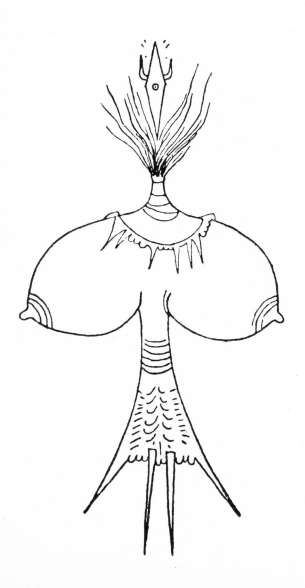

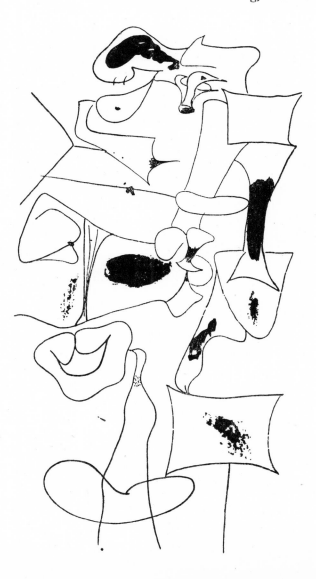

JORGE CAMACHO: *Drawing*, 1967

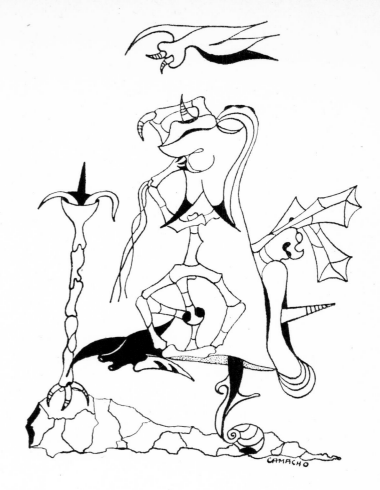

THE LAST SURREALISTS

The end of the Second World War made it possible for Surrealist activity to be renewed in liberated Paris, to which, one after the other, most of the New York exiles returned. The reconstituted Surrealist group was considerably changed compared with the pre-war period. Some important personalities had gone for ever (Eluard, Tzara, Masson); some had remained abroad (Tanguy, Ernst); while others maintained only very loose and irregular contacts (Miró, Arp). But all these losses and absences seemed to be made up for by an influx of young poets and painters who during the war had either been isolated or had organized themselves into small underground groups.

The balance sheet of the war period, and simultaneously a mirror of contemporary group activity, was the International Exhibition of Surrealism held in Paris in 1947 and thematically centred upon the problem of the New Myth. It was the last big demonstration of true, living Surrealism, with a broad international response. A large number of the foremost personalities of contemporary art participated, a total of almost one hundred artists from all over the world. But none of the newcomers exerted a decisive influence on the existing form of Surrealist art, though several of the painters and sculptors later became important in other contexts (Riopelle, Calder, Noguchi, Richier, Donati, Serpan).

Towards the end of the forties Surrealism definitely lost its leading position among the avant-garde throughout the world and other trends moved to the fore. The Surrealist group, still under Breton's leadership, did continue in existence, but their sphere of action became increasingly limited. Nonetheless, in the course of the fifties a number of new painters joined it, though few proved to be really interesting personalities.

One of them was the Hungarian painter SIMON HANTAI. His drawings of mandragora-shaped, bat- and bird-like beings seem to resuscitate the long-forgotten deities of ancient mythologies. Another group of Hantai's drawings with predominantly automatic components suggests elementary tellurian processes and more or less abstract structures which were given concrete form in certain collage details. In 1955 automatism led Hantai to Lyrical Abstraction. When he adopted the ideological position of Georges Mathieu he cast off all ties with Surrealism.

In 1953 the Surrealists discovered the Swedish painter MAX WALTER SVANBERG, who enhanced the Surrealist myth of woman with entirely novel forms of expression. Svanberg's woman was both a miraculous, mythical, fairy-tale, dream-world creature and a real being of a thousand forms, the subject of endless metamorphoses dictated by desire and an unusually rich poetical imagination.

Woman is also the sole theme of the erotic pictures and drawings of PIERRE MOLINIER, who transferred the Bellmer tradition of ingenious perversion to a somewhat vulgar waxwork setting. Their crude, dilettante execution reveals a certain link with the provocatively bad painting of Picabia's "monsters".

42

Bizarre and grotesque eroticism also dominates the drawings in coloured crayons of the self-taught Berlin artist FRIEDRICH SCHRÖDER-SONNENSTERN, whose interesting and authentic work shows a certain relationship with the work done by spiritualist mediums and the mentally deranged.

Apart from these few artists the Surrealist group in the fifties included others whose very membership is indicative of the sudden decline of Breton's formerly faultless artistic intuition. One other aspect is a further sign of the malaise. Before, the best works of art had come into being inside the group or within reach of its influence; but in the fifties Surrealism can mostly be detected in works that came about under different circumstances and were appropriated by the Surrealists in a finished form. The respective artist's later participation in group activity did not alter it in any substantial way. Moreover, these were often individualistic artists who occupied marginal positions outside the main current of development.

The Surrealists tried to keep in touch with some contemporary trends in art, particularly those that they regarded as their illegitimate heirs. Through the mediation of Charles Estienne they made contact, in the first half of the fifties, with some representatives of Lyrical Abstraction, whose method derived from graphic automatism but was used for purely artistic purposes, not for interpretative ones. This attempt to revive Surrealism did not last long, although for a time it did bring into their ranks artists like Degottex, Duvillier and Loubchansky. Within a few years the Surrealists again cast doubt on Lyrical Abstraction as a purely aesthetic method which did not and could not, in their view, serve as a medium of knowledge. In reality, this is true solely of the greater part of its fashionable and superficial applications.

A second attempt was made ten years later, when some contacts were established between the Surrealists and selected representatives of new objective trends — Pop Art, New Realism, New Figuration, which, to some extent, followed up the Surrealist object or Magritte's illusionism. The greatest gain in all this was the loose co-operation of several important personalities of the new trends at Surrealist exhibitions, but this did not greatly affect the activity of the Surrealist group (Enrico Baj, Konrad Klapheck, Hervé Télémaque, Alberto Gironella). The initiator of this contact, José Pierre, admitted that the work of these artists remained rather distant from Surrealist painting as represented, in the sixties, by the work of Jorge Camacho and Jean-Claude Silbermann, leaving aside older artists.

The work of the Cuban painter JORGE CAMACHO evokes the oppressive and threatening atmosphere of torture-chambers, giving evidence of the inborn cruelty of man, who uses his ingenuity not only to master nature but also to invent ever more refined methods of torturing his fellow-man.

The main contribution of the French painter JEAN-CLAUDE SILBERMANN was his fantastic "signboards", while in his drawings he returned to what is virtually Art Nouveau-type vegetal decoration.

The increasing isolation of Surrealism led André Breton to turn this fact into a programme. The last International Exhibition of Surrealism, held in 1965, bore the demonstrative title "L'Ecart Absolu". It confirmed once and for all that Surrealism had finally parted company with the living streams of contemporary art. This is proved, among other things, by the fact that more than half of the exhibits were retrospective while — with the exception of Toyen, Matta, Lam, Svanberg and Camacho — the rest included artists of secondary importance (if we leave aside those who were invited to participate from outside).

Breton's attempts to make the movement occult led Surrealism in the end into a blind alley. Its immediate influence was reduced to a narrow circle of initiates who were willing to preserve the ideological purity that increasingly resembled petrification of thought, dogmatic stereotype handed down from the once living movement of the thirties and forties. This does not mean that the very essence of Surrealism, the attempt to comprehend man's unconscious life, to merge reality and dream, to create a new myth, lost its topical impact.

The attainment of these basic aims of Surrealism now seems even more urgent than ever before. If it is achieved one day, it will probably be through means different from those chosen by Surrealism in the final years of its existence. A series of Surrealist ideas have been developed ever since the thirties in non-orthodox and modified versions outside the group (Artaud, Bataille, Caillois). This trend has intensified in the post-war years and is particularly evident in the pictorial arts. Lyrical Abstraction, Action Painting, assemblages, environments, happenings — in many ways follow up the impulses sent out by Surrealism.

It was this fact — among others — that made far-seeing individuals within the Surrealist group adopt the decision to disband the movement for ever. This very act will undoubtedly lead to a more objective assessment of Surrealism and to a more accurate appreciation of its influence on a number of trends and personalities in post-war art.

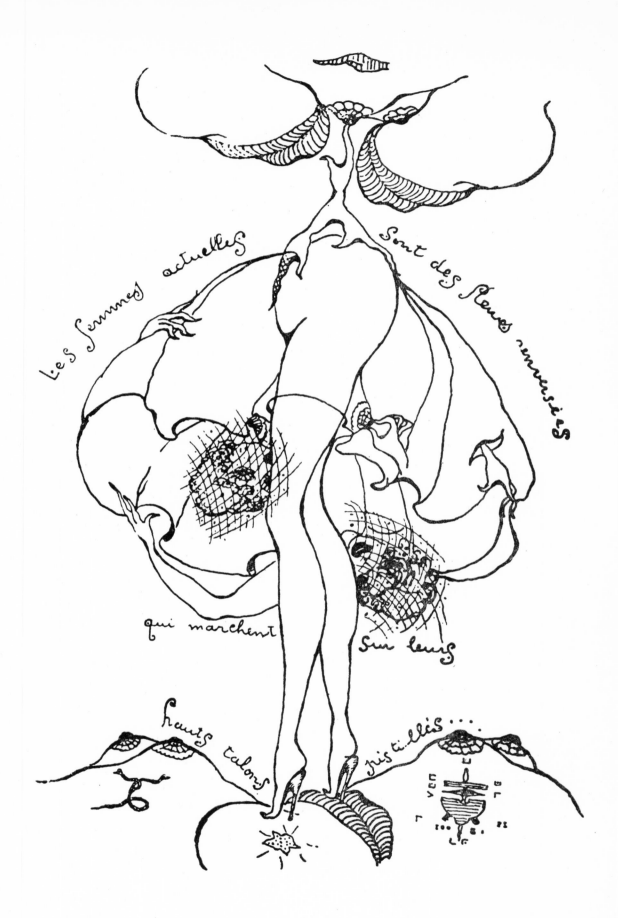

Pierre Molinier: *Drawing, c.* 1958

NOTES

1 "Le quatrième chant", *Le Monde* (4 October 1969)

2 *Le Surréalisme* (Lausanne 1966), p. 19

3 Eudo C. Mason, *The Mind of Henry Fuseli* (London 1951), p. 327

4 Victor Hugo, letter to his publisher Castel (5 October 1862); quoted in Gaëtan Picon, *Victor Hugo dessinateur* (Lausanne 1963), p. 97

5 "Gustave Moreau", in *Le Surréalisme et la peinture* (Paris 1965), p. 363

6 Ragnar von Holten, *Gustave Moreau, Symbolist* (Stockholm 1965), p. 79

7 Von Holten, *Gustave Moreau*, p. 197

8 Jean-Louis Bédouin, "Trop d'honneur", *Le Surréalisme, même* (Spring 1957), p. 100

9 William S. Rubin, *Dada and Surrealist Art* (New York 1968), p. 125—7

10 *Lettres d'Odilon Redon*, (Paris 1923), p. 34

11 Redon, *Lettres*, p. 33

12 *A soi-même* (Paris 1961), p. 28

13 *La Révolution surréaliste 12* (1929), p. 73

14 José Pierre, "Alfred Kubin et l'empire du rêve", *L'Abécédaie* (Paris 1971), p. 261

15 Alfred Kubin, *Die andere Seite* (Munich 1962), p. 191

16 Kubin, *Dämonen und Nachtgeschichte* (Dresden 1926), p. 35

17 Quoted in James Thrall Soby, *Giorgio de Chirico* (New York 1955), p. 244

18 *La Révolution surréaliste 1* (1924), p. 3. This is likely to be the record of an earlier dream corresponding to the period of his Italian piazzas (1912—14). It can almost certainly be identified with the picture *Melancholy of a Beautiful Day* (1913) — (coll. B. Goldschmidt, Brussels). A poetical paraphrase of the same dream is to be found in de Chirico's pre-war text "The Man with the Anguished Look" in the manuscript collection of Jean Paulhan.

19 "Une lettre de Chirico", *Littérature*, nouvelle série, 1 (1 March 1922), p. 11

20 Soby, *De Chirico*, p. 246

21 Rubin, *Dada and Surrealist Art*, p. 38

22 Max Ernst, *Beyond Painting* (New York 1948), p. 3

23 Ernst, *Beyond Painting*, p. 7

24 Ernst, *Frottages* (London 1969)

25 Ernst, *Beyond Painting*, p. 8

26 André Breton: *Second manifeste du surréalisme*, in *Manifestes du surréalisme* (Paris 1962), p. 154

27 Roland Penrose, *Miró* (London 1970), p. 47

28 Breton, *Manifestes*, p. 36

29 Breton, *Le Surréalisme et la peinture*, pp. 2—3

30 Breton, *Manifestes*, p. 28

31 "L'Art de la ressemblance", in *René Magritte*, catalogue, (Hanover 1969), pp. 10—11

32 "Les mots et les images", *La Révolution surréaliste* 12 (1929), p. 32

33 *The Conquest of the Irrational* (New York 1935)

34 Quoted in Breton, *Manifestes*, pp. 328—9

35 Oscar Dominguez, in Breton, *Le Surréalisme*, p. 129

SELECT BIBLIOGRAPHY

I GENERAL

Sarane Alexandrian, *Surrealist Art* (London 1970).

Anna Balakian, *André Breton, Magus of Surrealism* (New York 1971).

Alfred Barr Jr and Georges Hugnet, *Fantastic Art, Dada, Surrealism* (New York 1936).

André Breton, *Manifestos of Surrealism* (Ann Arbor, Mich. 1969).

André Breton, *Le Surréalisme et la peinture* (Paris 1965).

André Breton and Paul Eluard, *Dictionnaire abrégé du surréalisme* (Paris 1969).

André Breton and Gérard Legrand, *L'art magique* (Paris 1957).

R. Cardinal and R. S. Short, *Surrealism* (London 1971).

Enrico Crispolti, *Il Surrealismo* (Milan 1969).

David Gasgoyne, *A Short Survey of Surrealism* (London 1935).

Herbert Gerschman, *The Surrealist Revolution in France* (Ann Arbor, Mich. 1969).

Julian Levy, *Surrealism, a State of Mind, 1924—65* (Boston 1966).

Lucy Lippard (ed.), *Surrealists on Art* (New Jersey 1970).

Marcel Jean and Arpad Mezei, *History of Surrealist Painting* (London 1960; New York 1967).

Maurice Nadeau, *History of Surrealism* (London 1968).

José Pierre, *Le surréalisme* (Lausanne 1966).

Sir Herbert Read, *Surrealism* (London 1936).

William S. Rubin, *Dada and Surrealist Art* (New York 1968; London 1970).

Patrick Waldberg, *Surrealism* (London and New York 1966).

Patrick Waldberg, *Chemins de surréalisme* (Brussels 1965).

II MONOGRAPHS

ARP: Herbert Read, *Arp* (London 1970).

BELLMER: Constantin Jelenski, *Les dessins de Bellmer* (Paris 1966).

BRAUNER: Sarane Alexandrian, *Les dessins magiques de Victor Brauner* (Paris 1965).

de CHIRICO: James Thrall Soby, *Giorgio de Chirico* (New York 1955).

DALI: James Thrall Soby, *Salvador Dali* (New York 1946).

DELVAUX: Maurice Nadeau, *Les dessins de Paul Delvaux* (Paris 1967).

DUCHAMP: Robert Lebel, *Sur Marcel Duchamp* (Paris 1959).

ERNST: Werner Spies, *Max Ernst — Frottages* (London 1969).

FUSELI: Paul Ganz, *The Drawings of Henry Fuseli* (London 1949).

GORKY: Harold Rosenberg, *Arshile Gorky* (New York 1962).

HÉROLD: Michel Butor, *Jacques Hérold* (Paris 1964).

HUGO: Gaëtan Picon, *Victor Hugo dessinateur* (Lausanne 1963).

KUBIN: Wieland Schmied, *Der Zeichner Alfred Kubin* (Salzburg 1967).

LAM: Yven Taillandier, *Les dessins de Lam* (Paris 1971).

MAGRITTE: Patrick Waldberg, *René Magritte* (Brussels 1965).

MASSON: Michel Leiris, *Les dessins d'André Masson* (Paris 1971).

MATTA: William Rubin, *Matta* (New York 1957).

MIRÓ: Jacques Dupin, *Miró* (Paris 1961).

MOREAU: Ragnar von Holten, *L'Art fantastique de Gustave Moreau* (Paris 1960).

MUZIKA: František Šmejkal, *František Muzika* (Prague 1966).

OELZE: Wieland Schmied, *Richard Oelze*, catalogue (Hanover 1964).

PAALEN: José Pierre, *Domaine de Paalen* (Paris 1970).

PICABIA: Michel Sanouillet, *Francis Picabia* (Paris 1964).

PICASSO: Christian Zervos, *Dessins de Picasso* (Paris 1949).

REDON: André Mellerio, *Odilon Redon, peintre, dessinateur, graveur* (Paris 1923).

ŠTYRSKÝ: František Šmejkal, *Jindřich Štyrský — Rêves* (Prague 1970).

TANGUY: James Thrall Soby, *Yves Tanguy* (New York 1965).

TOYEN: André Breton and Benjamin Péret, *Toyen* (Paris 1953).

LIST OF TEXT FIGURES

frontispiece: Max Ernst: *Portrait of André Breton*, 1924

p. 10 Joan Miró: *Pastorale*, 1924

p. 13 André Masson: *Lovers*, 1925

p. 17 Francis Picabia: *Guillaume Apollinaire*, 1917

p. 19 Man Ray: *Object of Destruction*, 1932

p. 21 Jean Arp: *Automatic Drawing*, 1916

p. 21 André Masson: *Emblematic Man IV*, 1940

p. 24 Joan Miró: *Drawing*, 1956

p. 27 René Magritte: *Androgyne's Dream*, 1938

p. 28 Salvador Dali: *The Dream of the Apparition of an Emblem*, 1937

p. 30 Alberto Giacometti: Sketch for *The Palace at 4 a. m.*, 1932

p. 33 Oscar Dominguez: *The Memory of the Future*, 1938

p. 34 Wolfgang Paalen: *The Dream of the Floes*, 1938

p. 36 Toyen: Drawing from the cycle *The Shoot*, 1939

p. 37 Josef Šíma: *Old Tree*, *c.* 1927

p. 38 Toyen: *The Remains of the Dreams*, 1966

p. 40 Matta: *Drawing*, 1943

p. 41 Wilfredo Lam: *Drawing*, 1954

p. 41 Arshile Gorky: *Drawing*, 1945–6

p. 42 Jorge Camacho: *Drawing*, 1967

p. 44 Pierre Molinier: *Drawing*, *c.* 1958

LIST OF PLATES

1 Henry Fuseli: *The Nightmare*, *c.* 1810; pencil, watercolour, 32 × 40.5 cm (Kunsthaus, Zurich).

2 Victor Hugo: *Dwarf of the Night*, 1856; ink, sepia, gouache, watercolour and probably coffee, 38 × 24 cm (Maison de Victor Hugo, Paris; photo Roger Viollet).

3 Gustave Moreau: *The Temptation of St Anthony*, *c.* 1890; watercolour, 14 × 24 cm (Musée Gustave Moreau, Paris; photo Bulloz).

4 Odilon Redon: *Eye with Poppy-Head*, 1892; charcoal, 46 × 32 cm (coll. Claude Roger Marx, Paris; photo Bulloz).

5 Alfred Kubin: *The Dream of a Serpent*, *c.* 1905; pen, washed Indian ink, 27 × 20.2 cm (Albertina, Vienna).

6 Giorgio de Chirico: *Joy*, 1913; pencil, 16.5 × 21.6 cm (coll. Sir Roland Penrose, London; photo Brompton Studio).

7 Giorgio de Chirico: *Faithful Servant*, 1918; pencil, 24 × 16 cm (Galleria Alexandre Iolas, Milan).

8 Francis Picabia: *Conversation*, 1922; watercolour, 29 × 70 cm (Tate Gallery, London).

9 Max Ernst: *Erectio sine qua non*, 1919; pencil, watercolour, frottage, 46.4 × 30.8 cm (private collection, Turin).

10 Max Ernst: *Head*, 1925; frottage, 45 × 33 cm (Galerie Alexandre Iolas, Paris).

11 Max Ernst: *Head*, 1925; frottage, 32 × 25 cm (Galerie Alexandre Iolas, Paris).

12 Max Ernst: Illustration for René Crevel's book *Mr Knife and Miss Fork*, 1931; frottage, 18.5 × 12.5 cm (private collection, Paris; photo Jacqueline Hyde).

13 André Masson: *Female nude*, 1926; pastel, 63 × 48 cm (Galerie Louise Leiris, Paris).

14 André Masson: *Cock-Fight*, 1929; pen, Indian ink, tempera, sand and collage, 62 × 47 cm (private collection, Brno; photo Jiří Hampl).

15 André Masson: drawing from the cycle *Mythology of Being*, 1938; pen, Indian ink, 46 × 54 cm (private collection, Paris; photo Jacqueline Hyde).

16 Joan Miró: *Drawing*, 1934; pen, Indian ink, watercolour, 28 × 25.5 cm (private collection, Paris; photo Galerie Le Point Cardinal).

17 Joan Miró: *Woman*, 1934; pastel, 106 × 71 cm (private collection, Paris).

18 Yves Tanguy: *Drawing;* pen, Indian ink, 37.5 × 26 cm (Galerie André-François Petit, Paris; photo Jacqueline Hyde).

19 Yves Tanguy: *Drawing,* 1953 (illustration for Jean Laude, *Le Grand Passage*); pen, Indian ink, 34 × 32.5 cm (private collection, Paris; photo Jacqueline Hyde).

20 René Magritte: *La joie de vivre,* 1963; gouache, 31.5 × 27 cm (Galerie Alexandre Iolas, Paris).

21 René Magritte: *Unexpected Reply,* 1964 (variation on a picture by the same name of 1933); gouache, 54 × 35 cm (Galerie Alexandre Iolas, Paris).

22 René Magritte: *Reeds,* 1964; pencil, 23 × 30.5 cm (Galerie Alexandre Iolas, Paris).

23 Salvador Dali: Study for *The Great Masturbator,* 1929; watercolour, 14 × 9 cm (Galerie André-François Petit, Paris).

24 Salvador Dali: *A Sleeping Woman, Lion, Horse . . . invisible,* 1929; pen, ink, coloured crayons, 32.5 × 42.5 cm (private collection, Brussels).

25 Salvador Dali: *Study for Dream, c.* 1931; pen, Indian ink, 19.5 × 19 cm (Galerie André-François Petit, Paris).

26 Salvador Dali: *Gradiva,* 1932; pen, Indian ink, 62 × 46 cm (Galerie André-François Petit, Paris).

27 André Breton, Yves Tanguy, Max Morise, Marcel Duhamel: *Exquisite Corpse, c.* 1926; coloured crayons, 28 × 22 cm (coll. Fernand Graindorge, Liège; photo Giraudon).

28 Pablo Picasso: *Surrealist Composition,* 1934; pen, washed Indian ink, 25 × 30 cm (Galerie Alexandre Iolas, Paris).

29 Victor Brauner: *Drawing,* 1930; pen, Indian ink, 56 × 39 cm (private collection, Paris).

30 Victor Brauner: *Drawing,* 1936; pen, Indian ink, 65 × 50 cm (private collection, Paris).

31 Victor Brauner: *Drawing,* 1964; pen, Indian ink, 65 × 50 cm (private collection, Paris).

32 Paul Delvaux: *Homage to Jules Verne,* 1971; watercolour, 15.9 × 21.2 cm (Galerie de Bateau-Lavoir, Paris, photo Jacqueline Hyde).

33 Paul Delvaux: *Night Train,* 1947; pen, Indian ink, watercolour (private collection, Brussels; photo Paul Bijtebier).

34 Paul Delvaux: *School of Savants,* 1958; pen, Indian ink, watercolour (private collection, Brussels; photo Paul Bijtebier).

35 Hans Bellmer: *Rape,* 1960; pencil, charcoal, white gouache, 60 × 45 cm (private collection, Basle).

36 Hans Bellmer: *Drawing,* 1960; pencil, white gouache, 63 × 48 cm (Galerie André-François Petit, Paris; photo André Morain).

37 Hans Bellmer: *Drawing,* 1960; pencil, chalk, 65 × 50 cm (Centre National d'Art Contemporain, Paris; photo André Morain).

38 Oscar Dominguez: *Decalcomania,* 1936 (private collection, Paris).

39 Wolfgang Paalen: *Fumage,* 1938 (private collection, Paris).

40 Richard Oelze: *Drawing, c.* 1955; pencil (coll. Konrad Klapheck, Düsseldorf).

41 Kurt Seligmann: *Drawing,* 1942; pen, Indian ink (private collection).

42 Jacques Hérold: *Drawing,* 1941; pen, Indian ink, 65 × 50 cm (Galerie de Seine, Paris).

43 Jindřich Štyrský: *The Omnipresent Eye,* 1936; pastel, transfer, 41 × 22.5 cm (private collection, Prague; photo Ladislav Neubert).

44 Jindřich Štyrský: *Drawing,* 1940; pencil, frottage, collage, 30.5 × 44 cm (National Gallery, Prague; photo Ladislav Neubert).

45 Jindřich Štyrský: *Dream of the Serpents III,* 1940; pencil, 25.2 × 21 cm (coll. Toyen, Paris; photo Jiří Hampl).

46 Toyen: *Composition,* 1933; Indian ink, watercolour, 47.5 × 31.5 cm (National Gallery, Prague; photo Ladislav Neubert).

47 Toyen: Drawing from the cycle *Day and Night,* 1943; pencil, charcoal, 28 × 17.5 cm (private collection, Prague).

48 Toyen: *Early Spring,* 1946; charcoal, tempera, 41 × 58 cm (coll. Josef Istler, Prague; photo Ladislav Neubert).

49 František Muzika: *Figure in a Landscape,* 1935; pencil, Indian ink, watercolour, 28 × 38 cm (coll. Milan Hegar, Prague; photo Ladislav Neubert).

50 František Muzika: *Great Dream,* 1942; pencil, pen, Indian ink, watercolour, 32 × 46 cm (private collection, Paris; photo Ladislav Neubert).

51 František Muzika: *Requiem*, 1944; charcoal, 48.5 × 63 cm (National Gallery, Prague; photo Jiří Hampl).

52 František Janoušek: *Drawing*, 1935; charcoal, coloured crayons, 72.5 × 58 cm (private collection, Prague; photo Ladislav Neubert).

53 František Janoušek: *Drawing*, 1935; charcoal, coloured crayons, 54 × 43 cm (private collection, Prague; photo Ladislav Neubert).

54 Alois Wachsman: *Drawing*, 1936; pen, Indian ink, watercolour, frottage, 27.9 × 42 cm (National Gallery, Prague; photo Ladislav Neubert).

55 Matta: *Drawing, c.* 1965; pastel (Galerie Alexandre Iolas, Paris).

56 Matta: Study for *Arrête l'âge d'Hémorre*, 1948; coloured crayons, 27 × 35 cm (private collection, Paris; photo Jacqueline Hyde).

57 Matta: *Par implosion: "A quelques heures de sa vie"*, 1967; coloured crayons, 50 × 60 cm (Galerie Alexandre Iolas, Paris; photo Jacqueline Hyde).

58 Wilfredo Lam: *Drawing*, 1951; pen, Indian ink, watercolour (Galerie Jacques Tronche, Paris).

59 Wilfredo Lam: *Drawing*, 1969; pastel (Galerie Maya, Brussels).

60 Václav Tikal: *Drawing*, 1942; pen, Indian ink, watercolour, 22.7 × 29.5 cm (National Gallery, Prague; photo Ladislav Neubert).

61 Václav Tikal: *Spring*, 1945; frottage, 28.5 × 23 cm (private collection, Prague; photo Jiří Hampl).

62 Josef Istler: *Nařvan I*, 1951; watercolour, 63 × 41.5 cm (Josef Istler collection, Prague; photo Ladislav Neubert).

63 Mikuláš Medek: *Head which Sleeps the Imperialist Sleep*, 1953; pencil, charcoal, 35.5 × 42 cm (private collection, Paris; photo Jiří Hampl).

64 Friedrich Schröder-Sonnenstern: *Drawing*, 1960; pastel (Galerie Jacques Tronche, Paris).

65 Simon Hantai: *Drawing*, 1953; pen, Indian ink (private collection).

66 Max Walter Svanberg: *Drawing*, 1958; pen, Indian ink (private collection).

PLATES

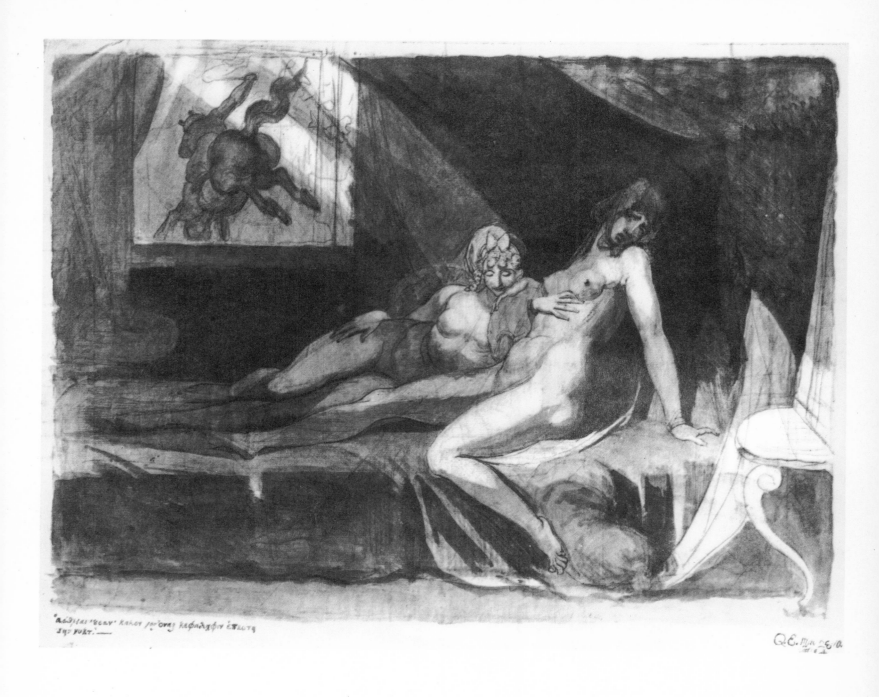

αἰδῆσαι θεᾶν κακον μ'ὁνας κεφαλῇσιν ἐπεισα
την νυκτ.'—

1 HENRY FUSELI: *The Nightmare*, c. 1810

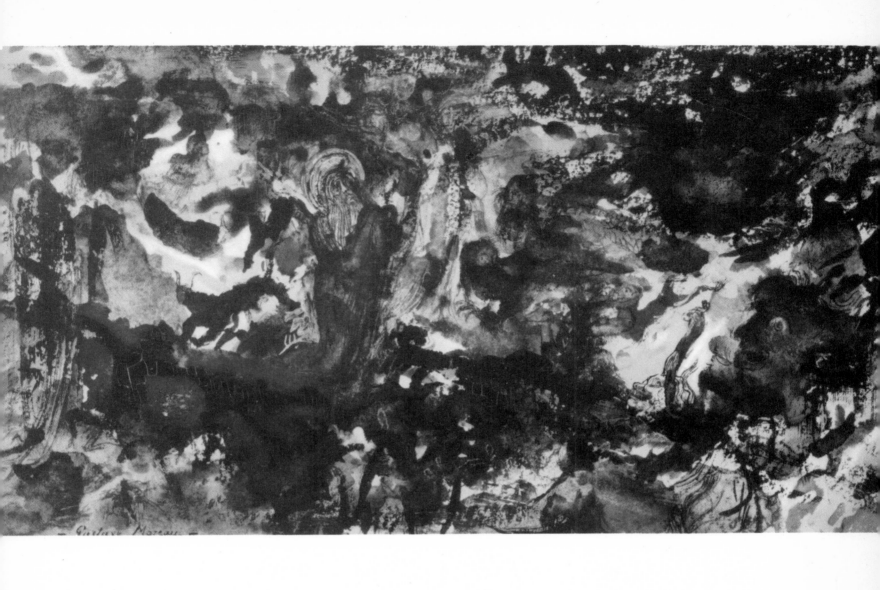

3 GUSTAVE MOREAU: *The Temptation of St. Anthony, c.* 1890

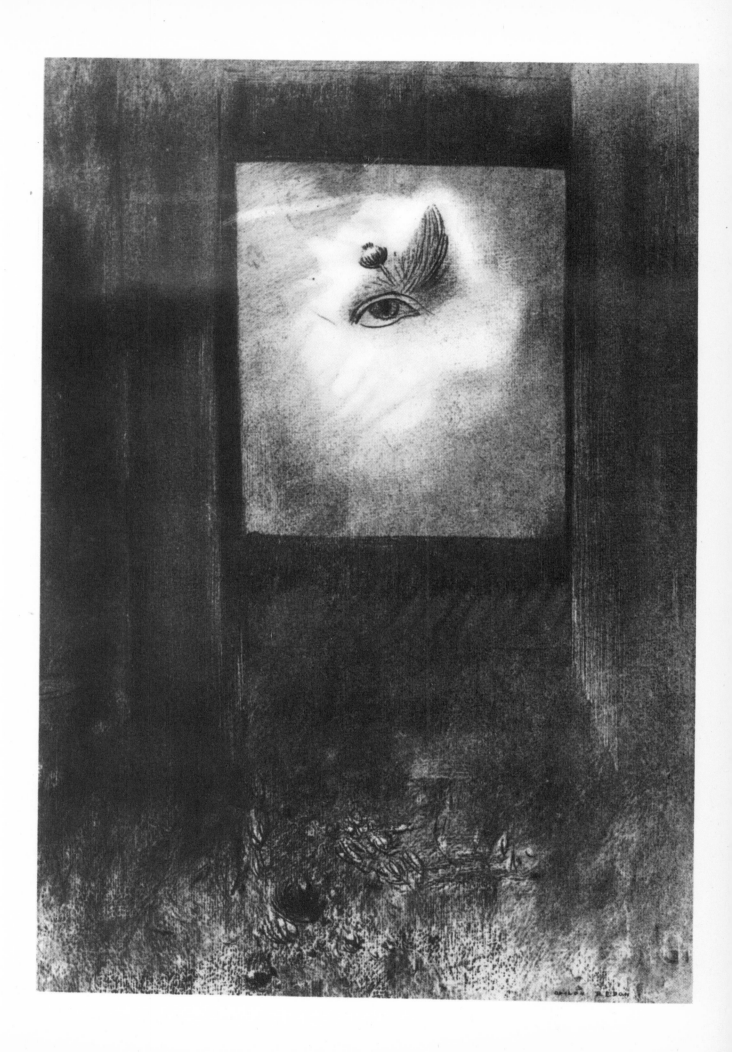

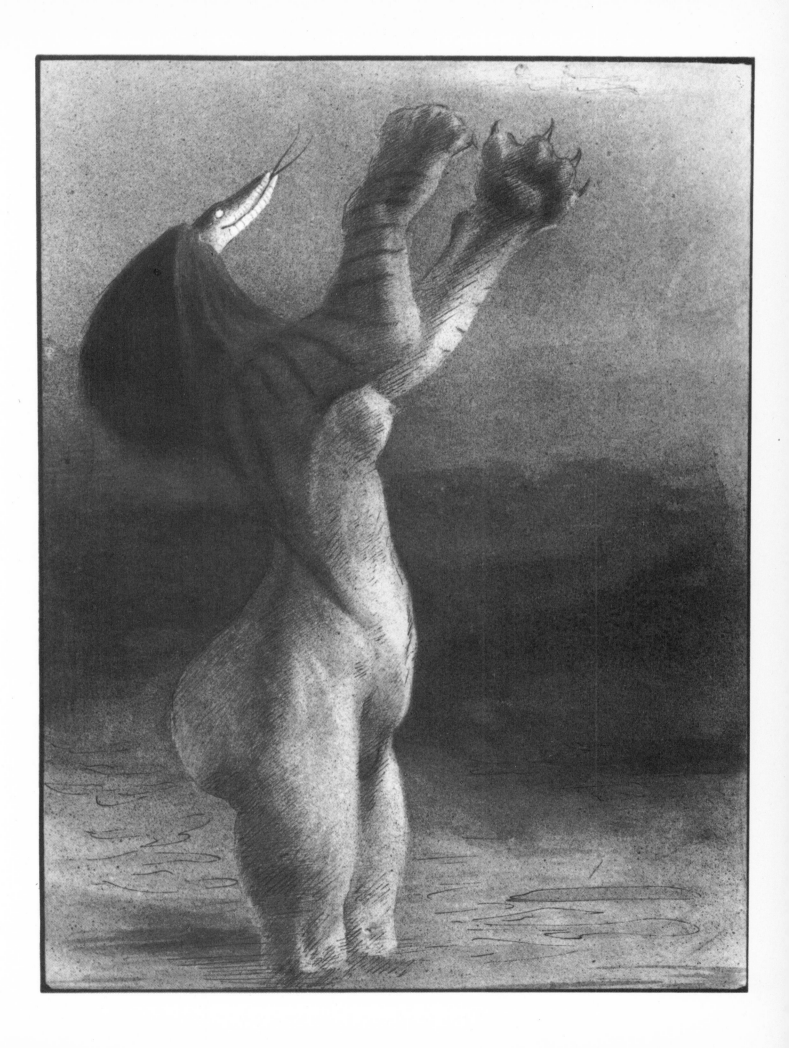

La Joie

6 GIORGIO DE CHIRICO: *Joy*, 1913

7 Giorgio de Chirico: *Faithful Servant*, 1918

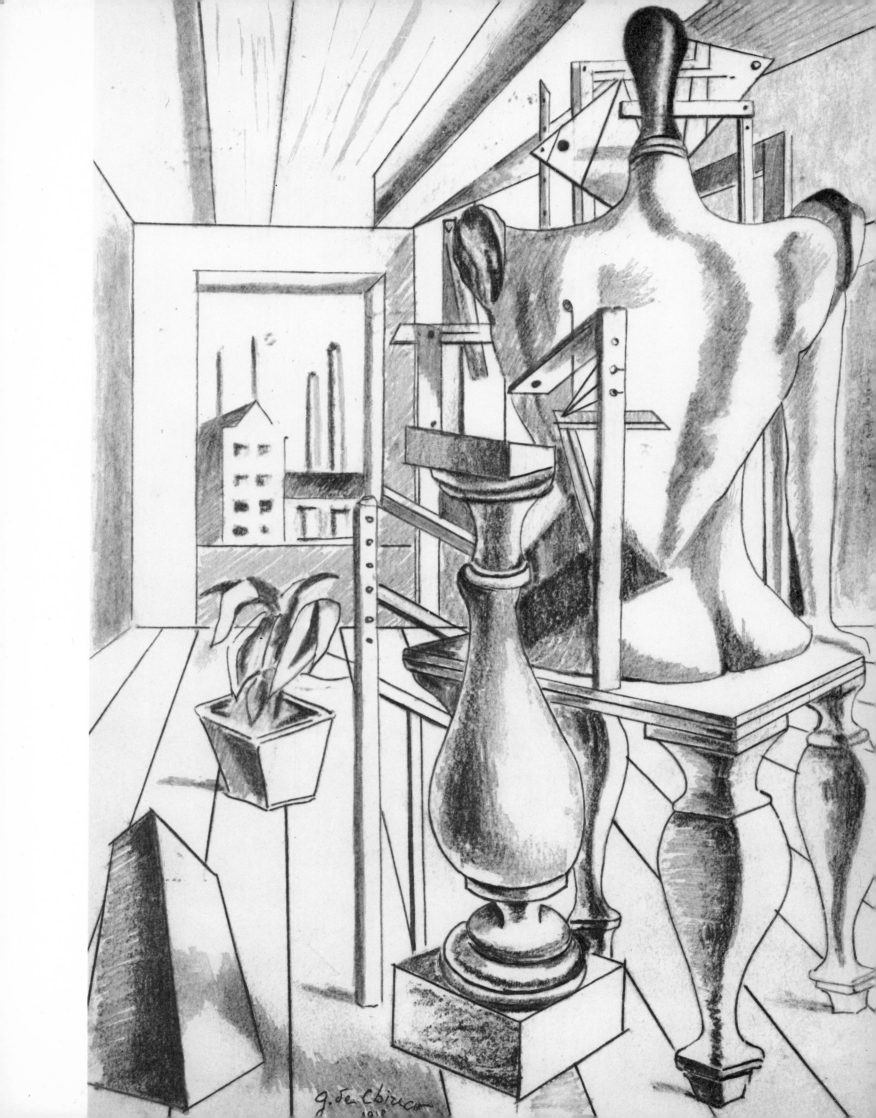

g. de Chirico
1918

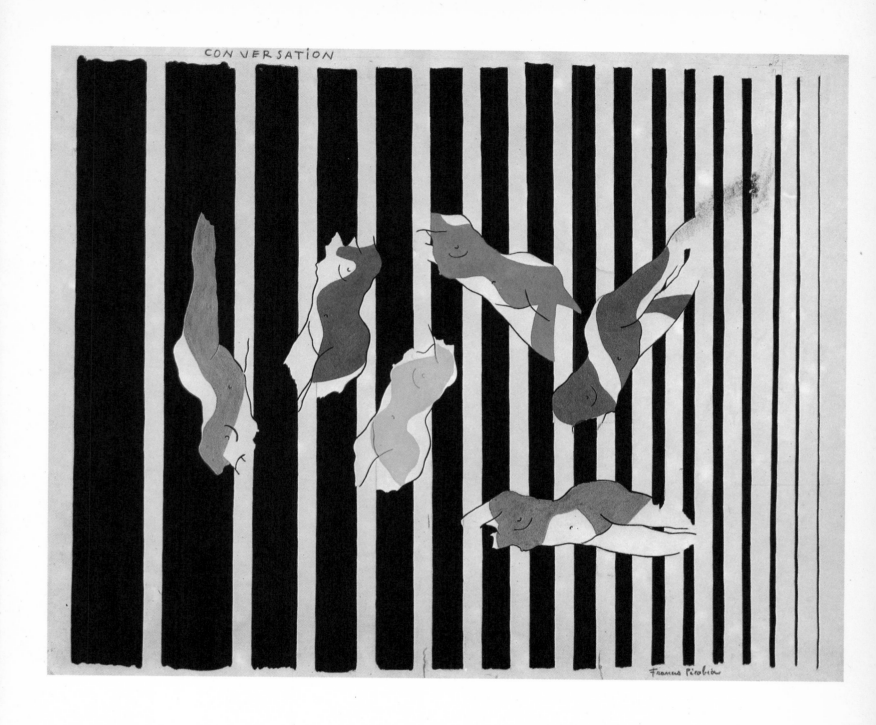

8 FRANCIS PICABIA: *Conversation*, 1922

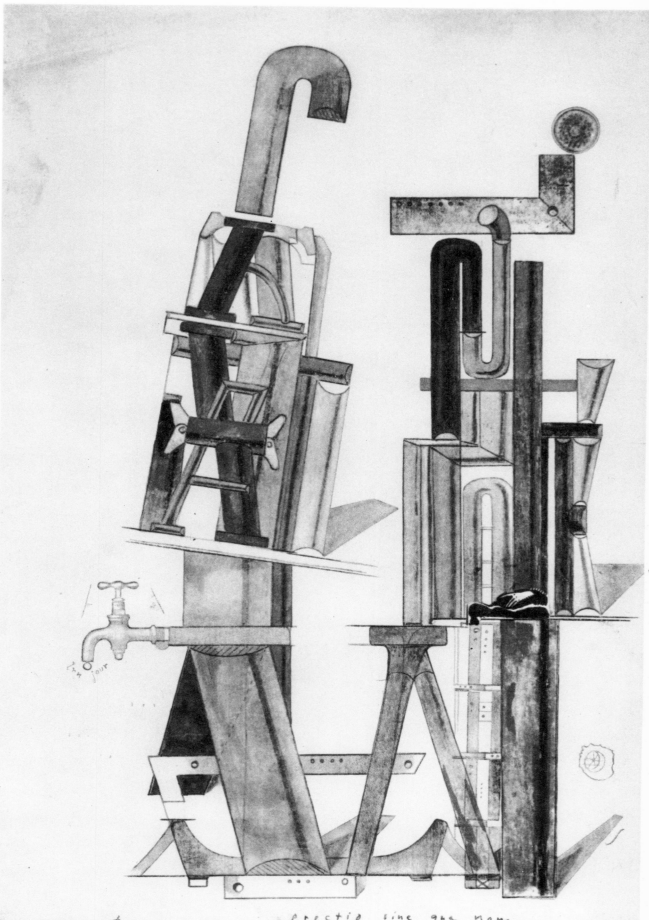

max ernst erectio sine qua non

11 Max Ernst: *Head*, 1925

12 Max Ernst: Illustration for René Crevel's book *Mr Knife and Miss Fork*, 1931

13 ANDRÉ MASSON: *Female nude*, 1926

14 ANDRÉ MASSON: *Cock-Fight*, 1929

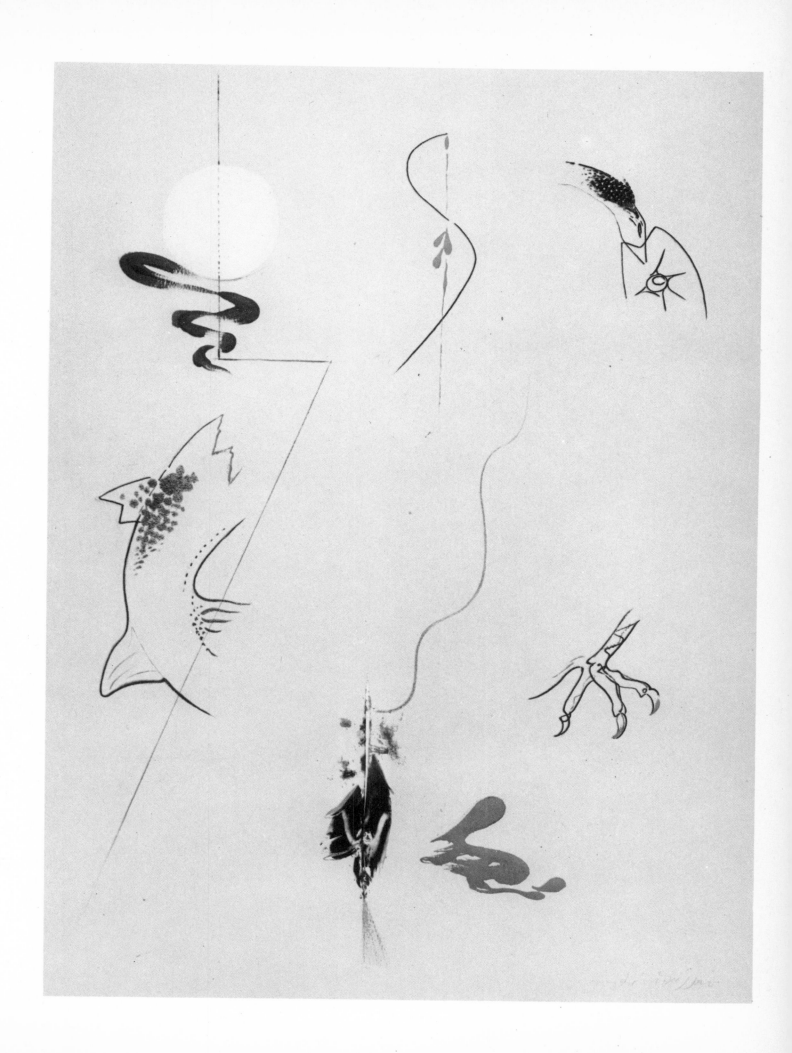

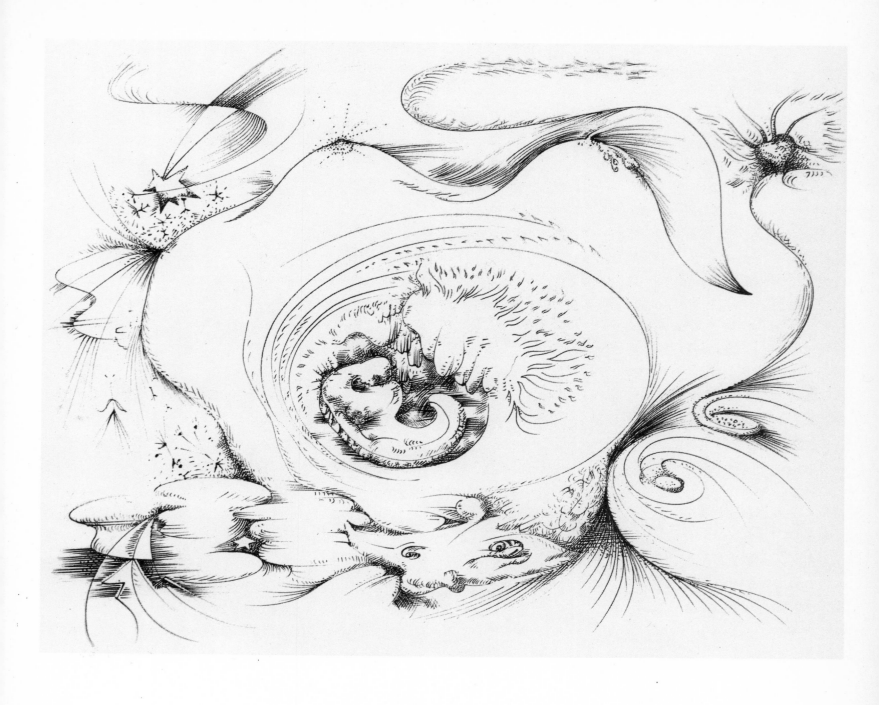

15 ANDRÉ MASSON: drawing from the cycle *Mythology of Being*, 1938

16 JOAN MIRÓ: *Drawing*, 1934

18 YVES TANGUY: *Drawing*

22 RENÉ MAGRITTE: *Reeds*, 1964

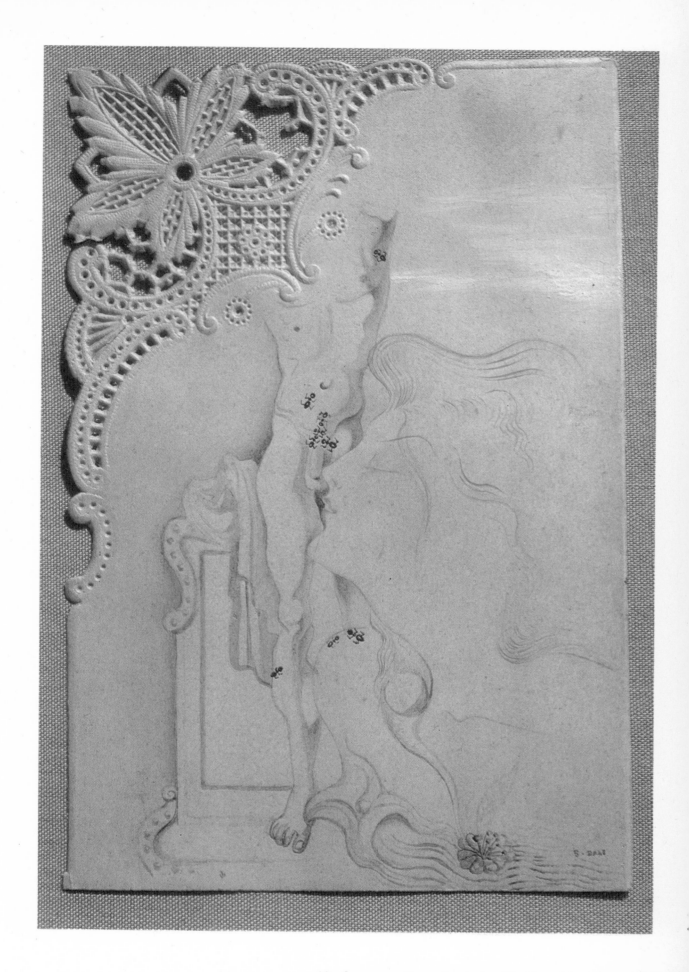

23 SALVADOR DALI: Study for *The Great Masturbator*, 1929

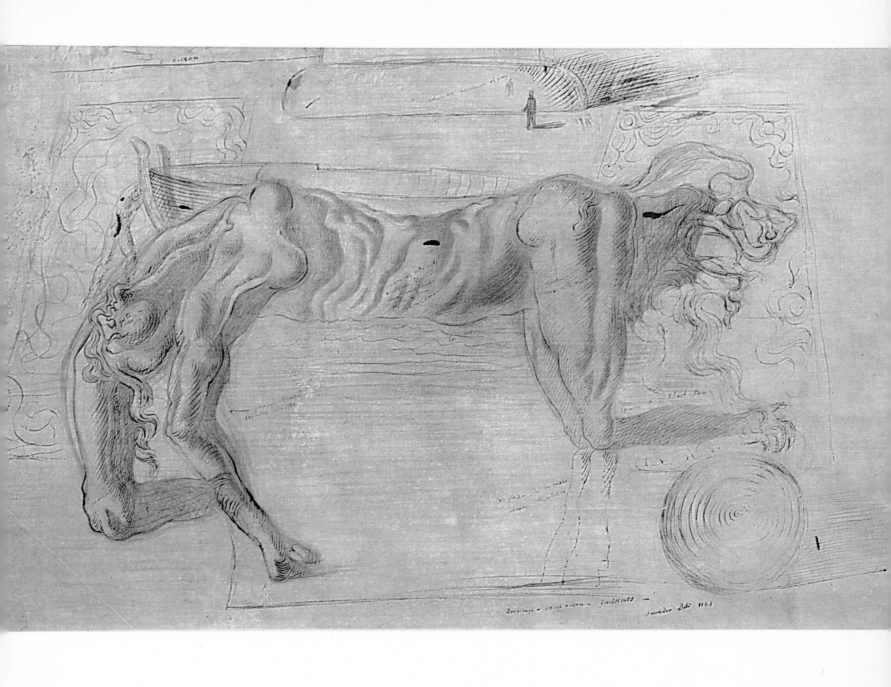

24 SALVADOR DALI: *A Sleeping Woman, Lion, Horse ... invisible*, 1929

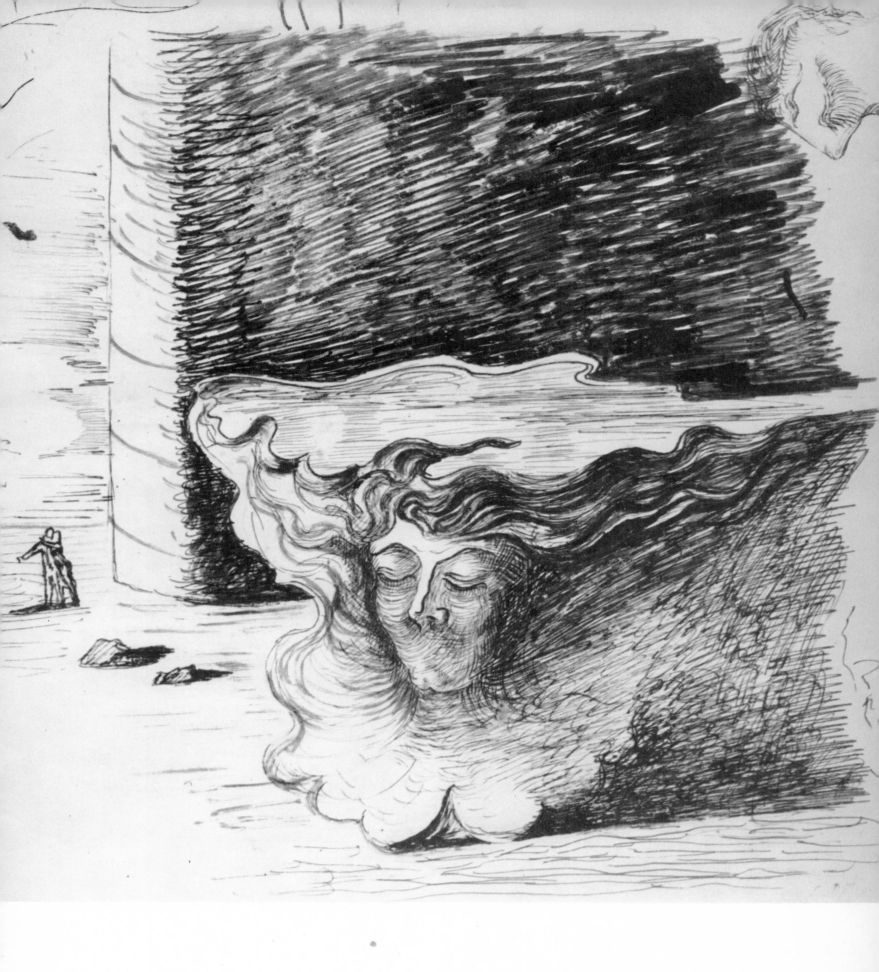

25 SALVADOR DALI: *Study for Dream*, c. 1931

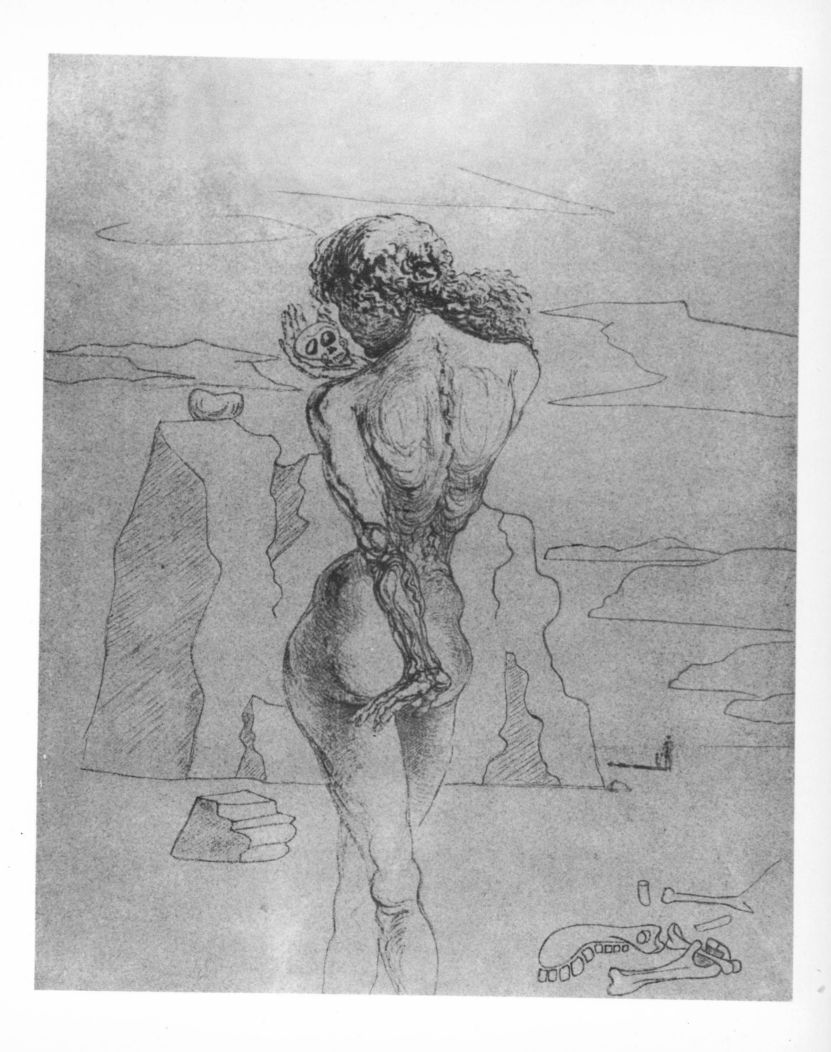

27 André Breton, Yves Tanguy, Max Morise, Marcel Duhamel: *Exquisite Corpse, c.* 1926

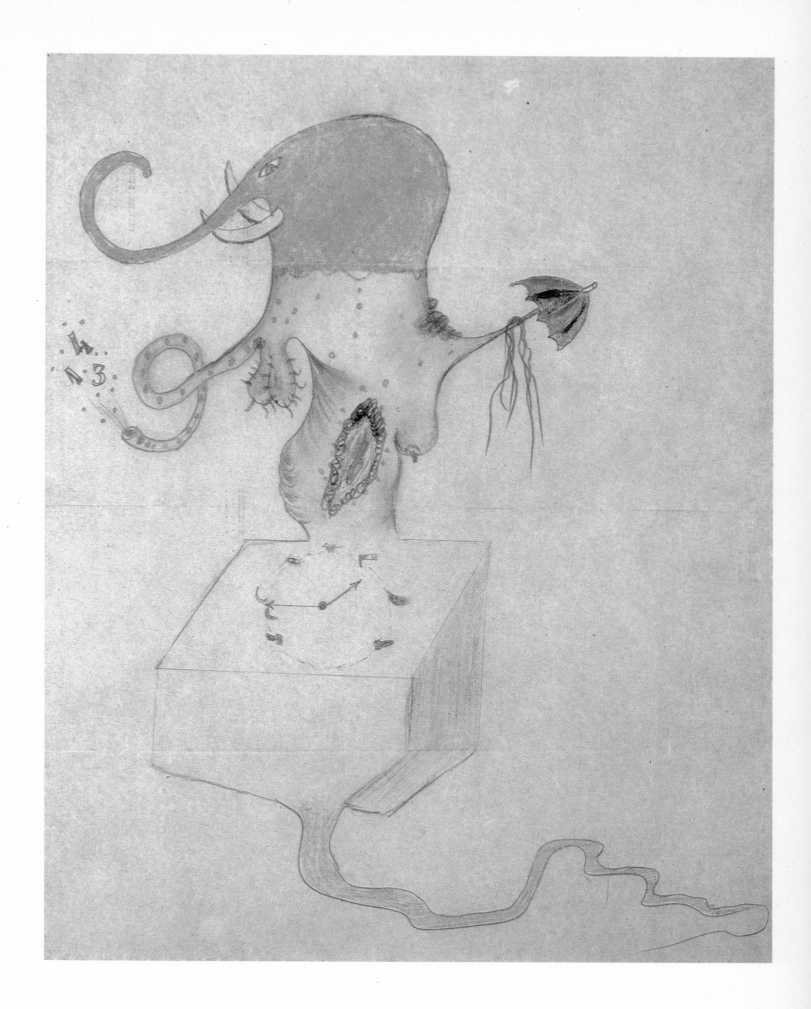

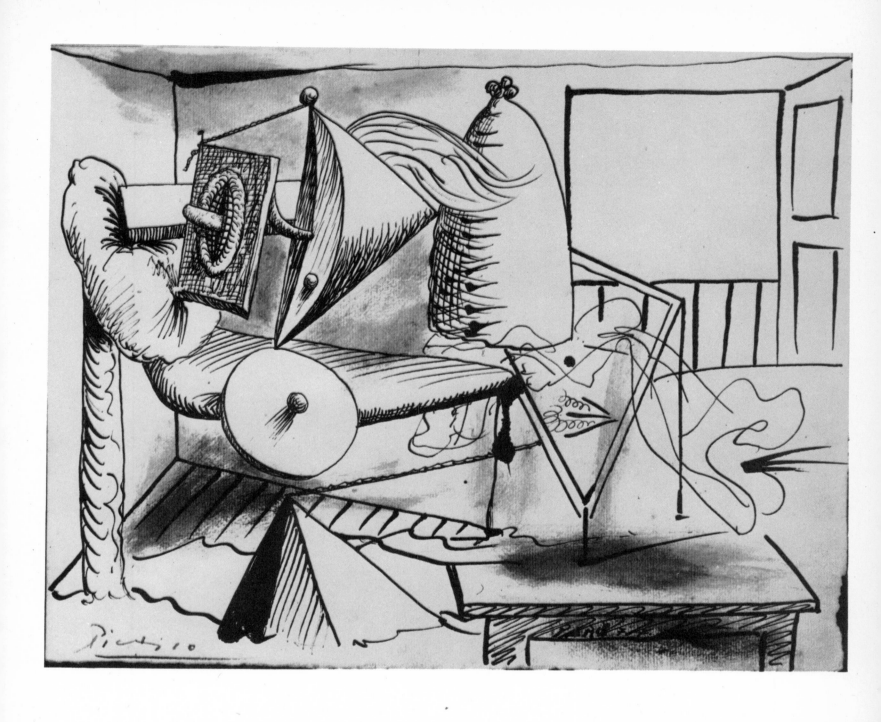

28 PABLO PICASSO: *Surrealist Composition*, 1934

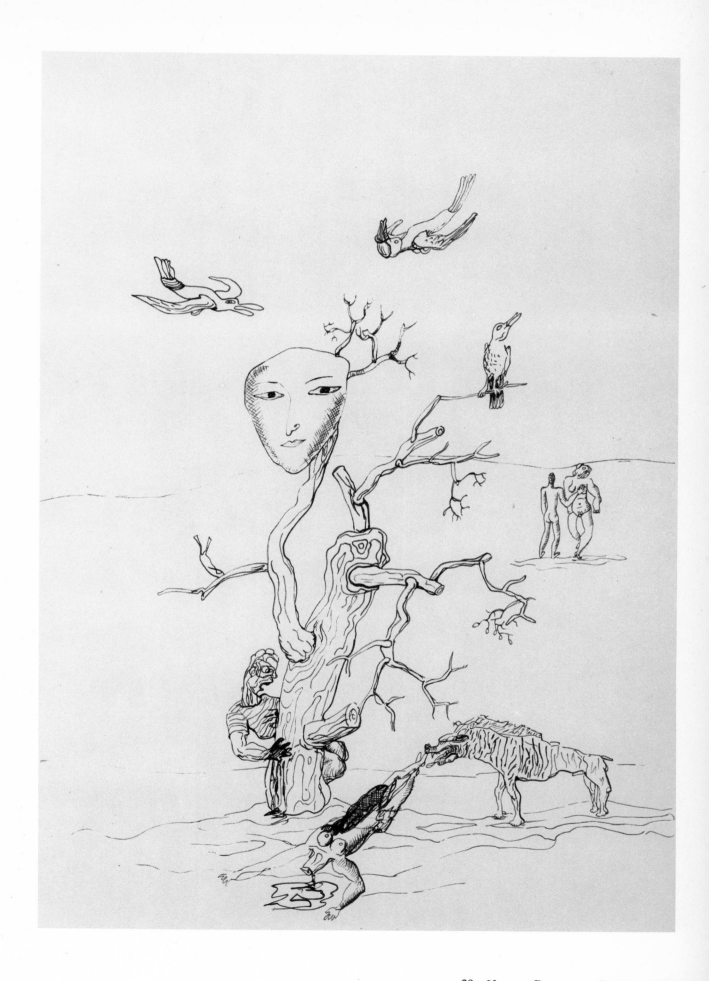

29 VICTOR BRAUNER: *Drawing*, 1930

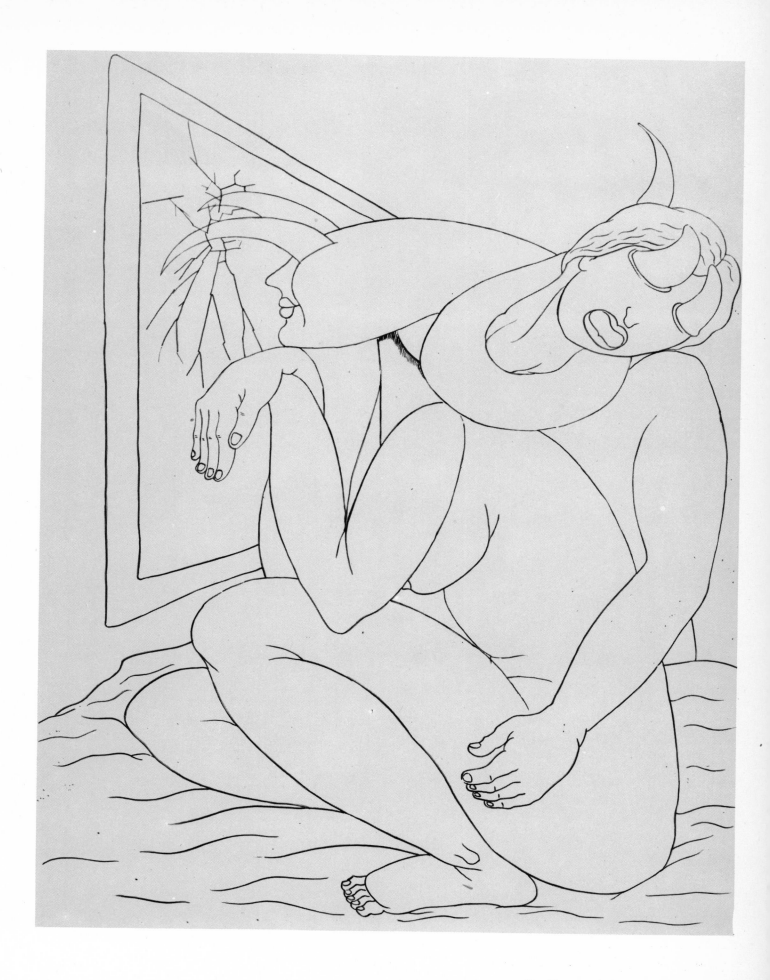

30 VICTOR BRAUNER: *Drawing*, 1936

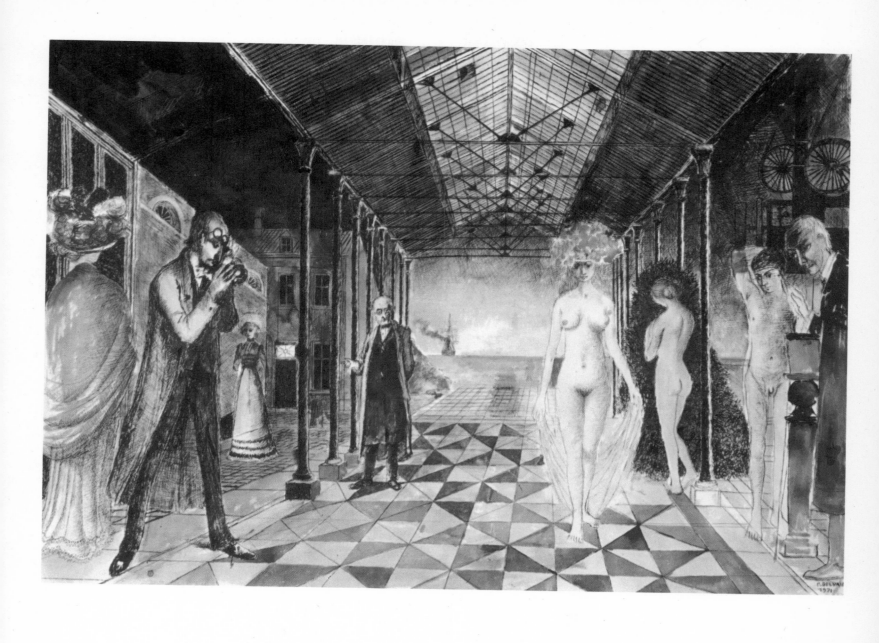

32 PAUL DELVAUX: *Homage to Jules Verne*, 1971

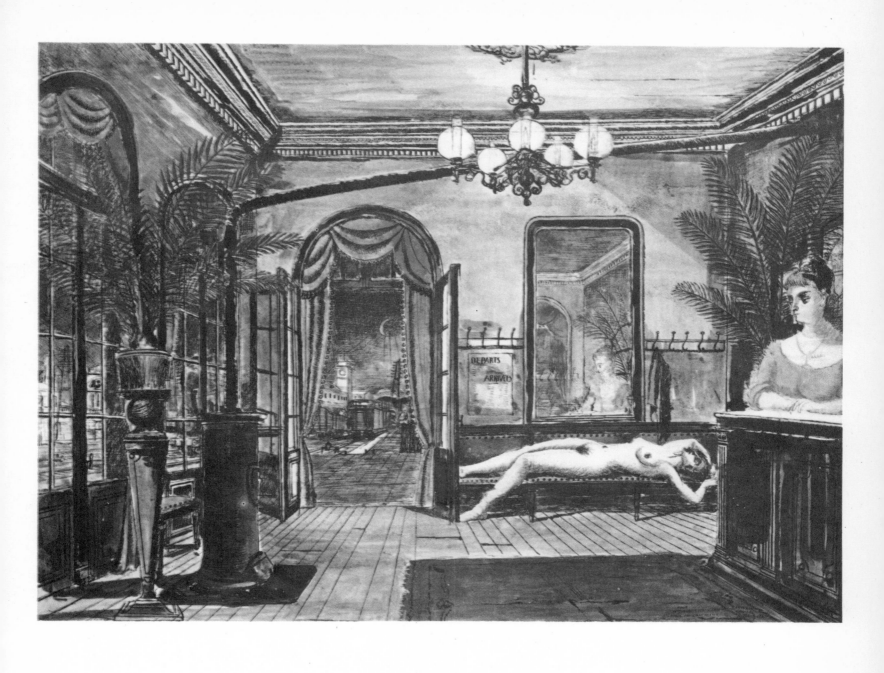

33 PAUL DELVAUX: *Night Train*, 1947

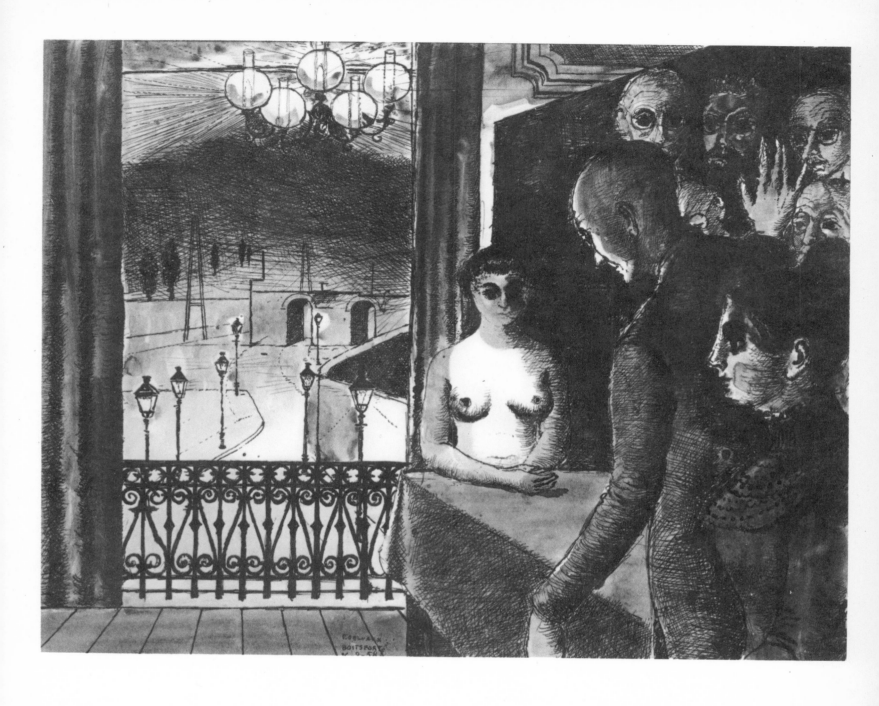

34 PAUL DELVAUX: *School of Savants*, 1958

35 HANS BELLMER: *Rape*, 1960

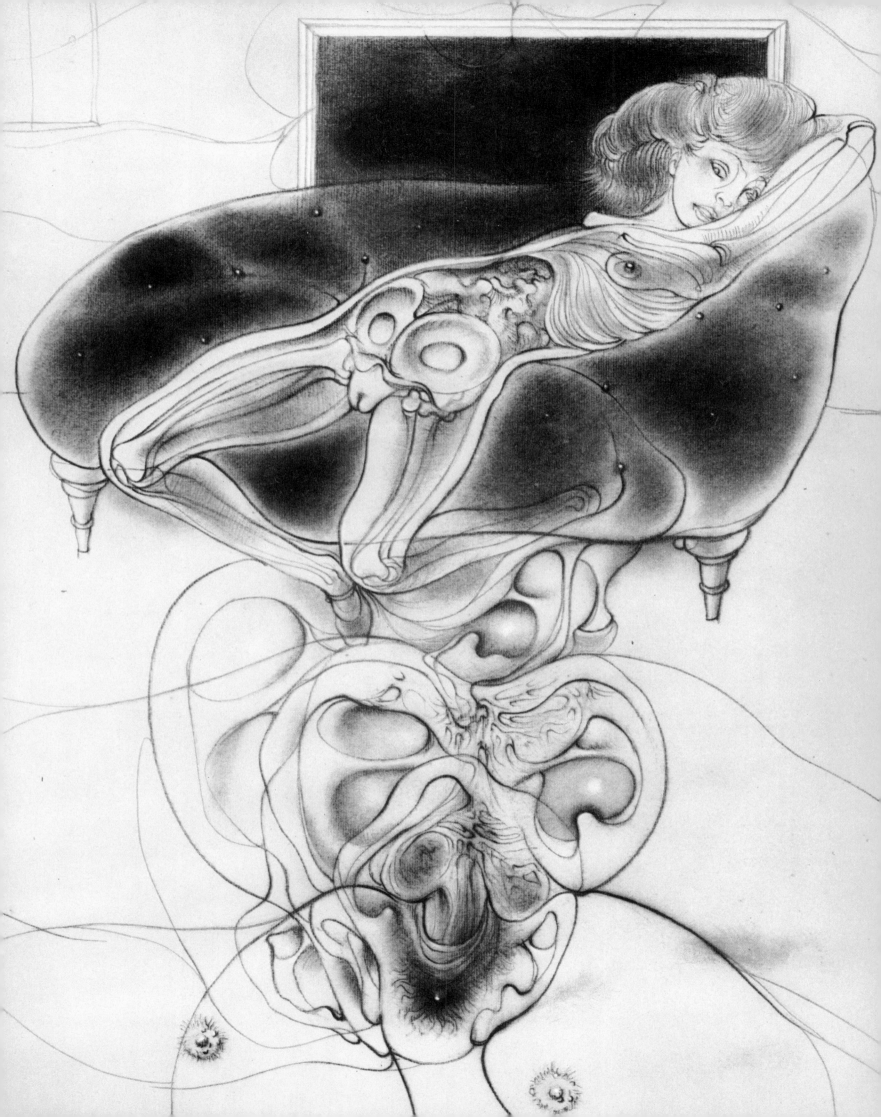

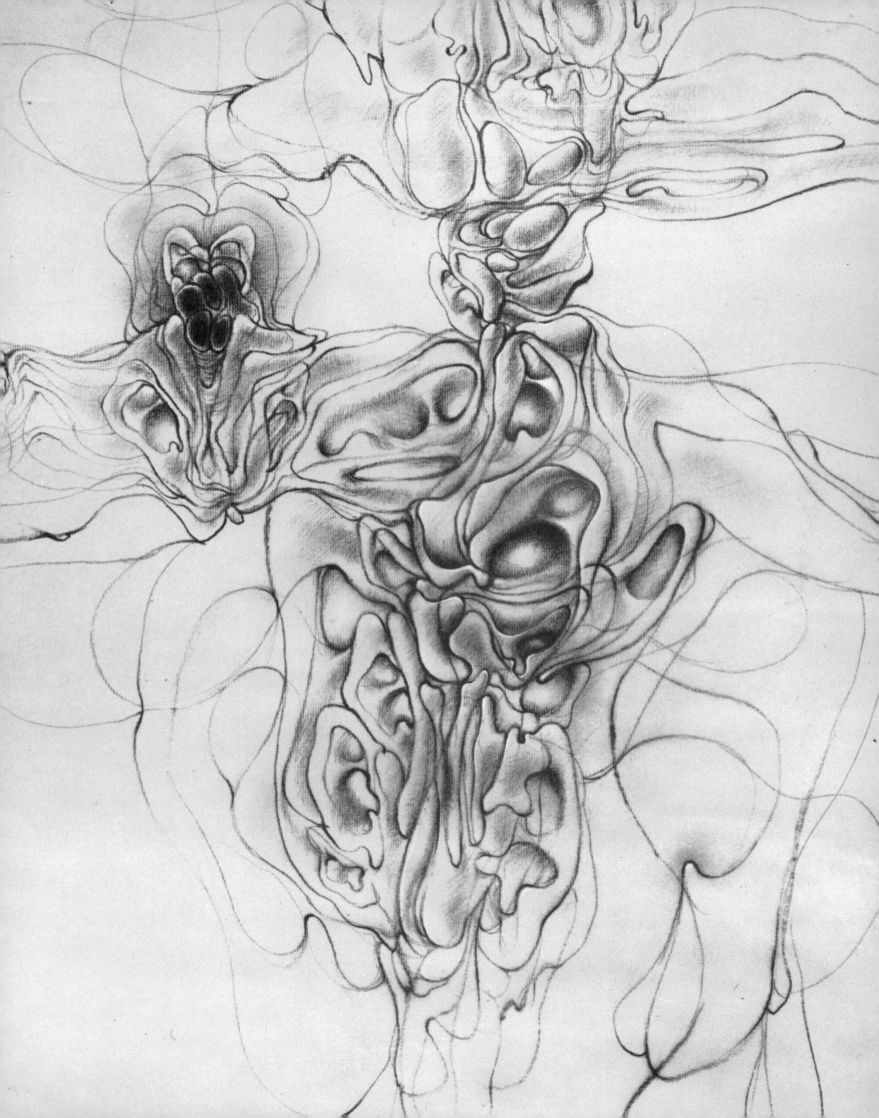

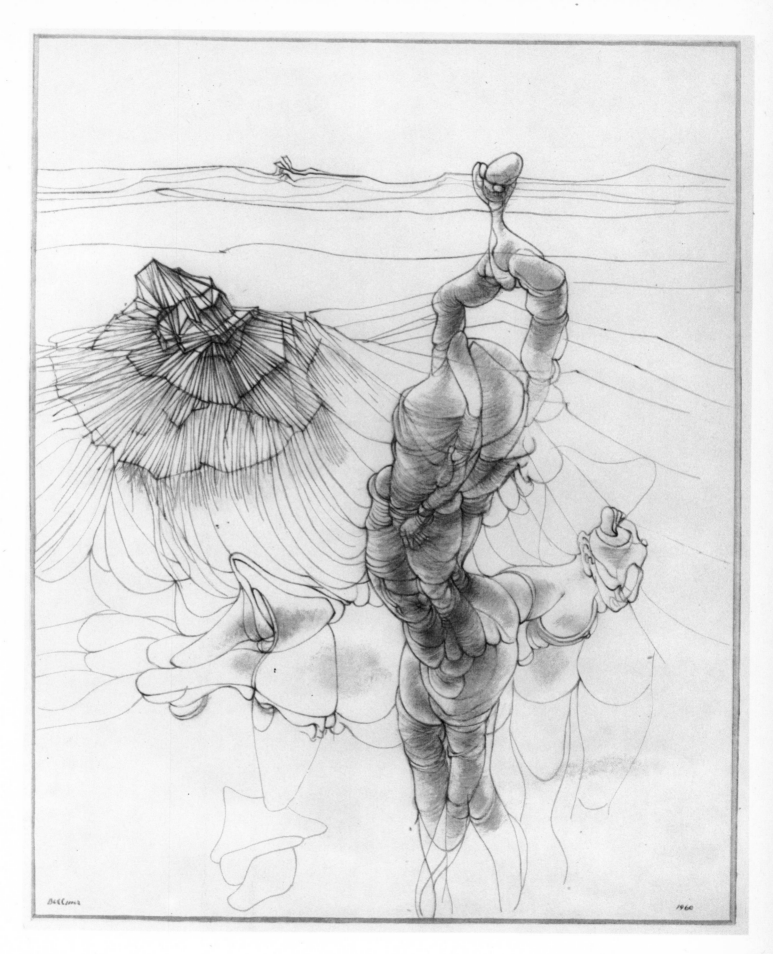

37 HANS BELLMER: *Drawing*, 1960

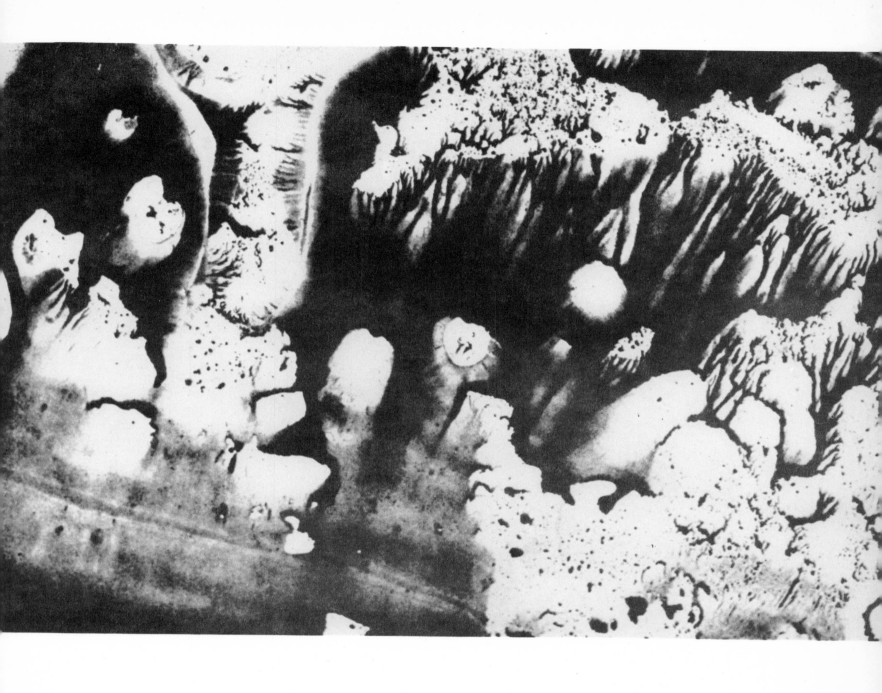

38 OSCAR DOMINGUEZ: *Decalcomania*, 1936

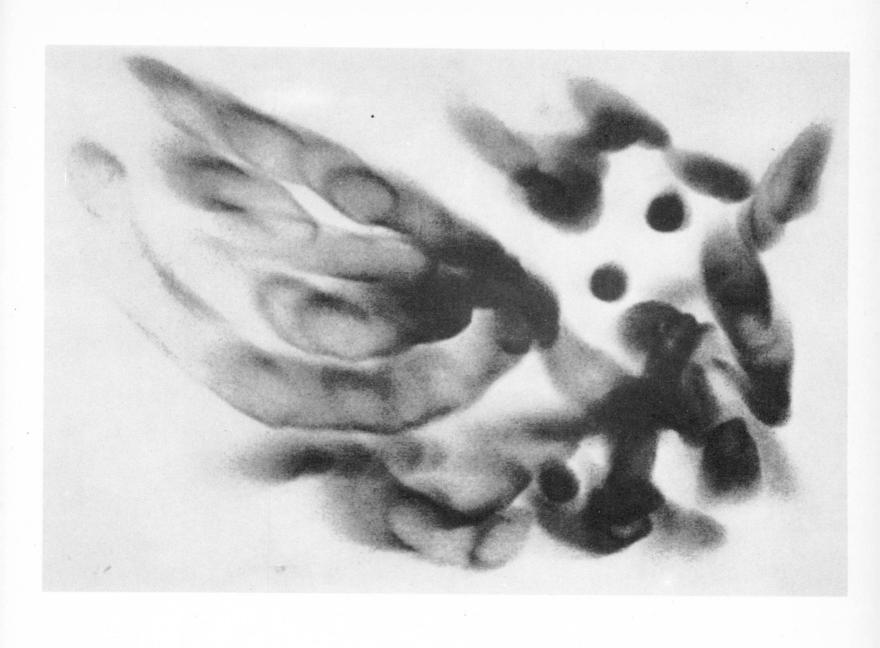

39 Wolfgang Paalen: *Fumage*, 1938

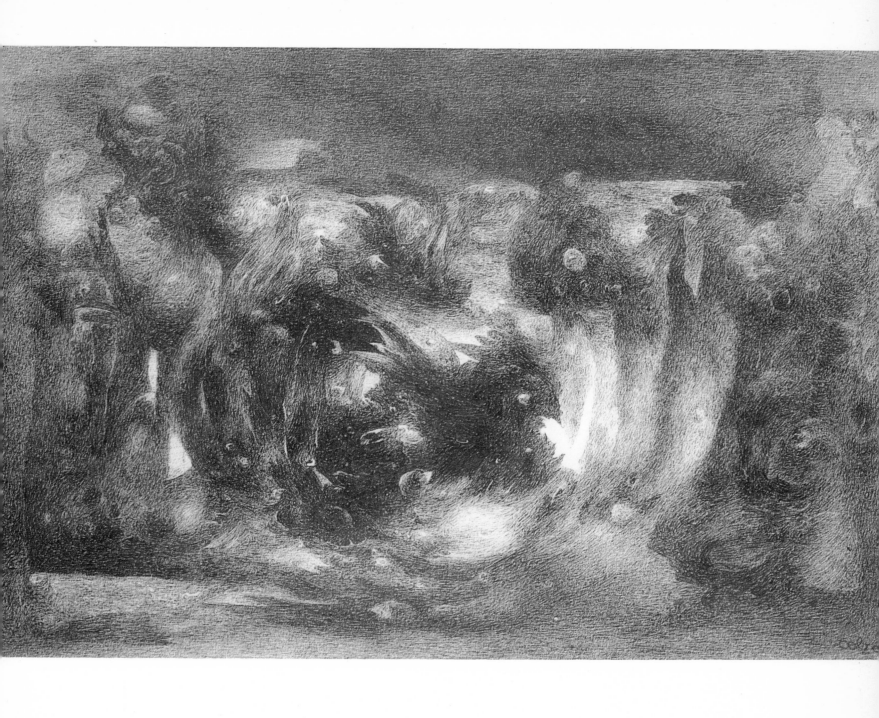

40 RICHARD OELZE: *Drawing, c.* 1955

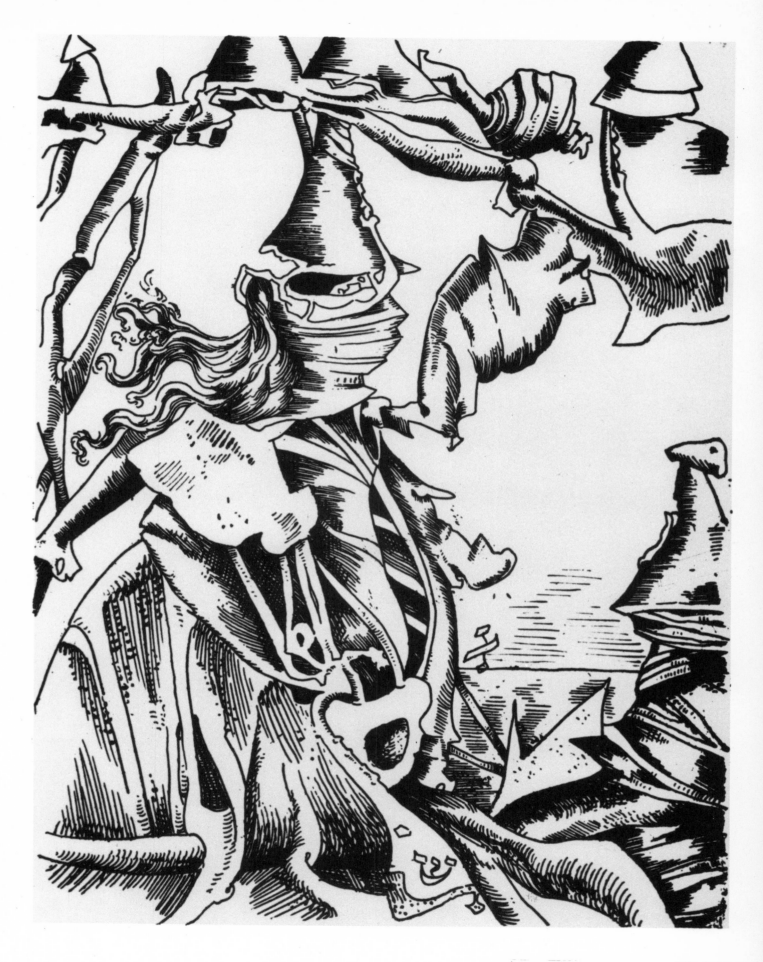

41 KURT SELIGMANN: *Drawing,* 1942

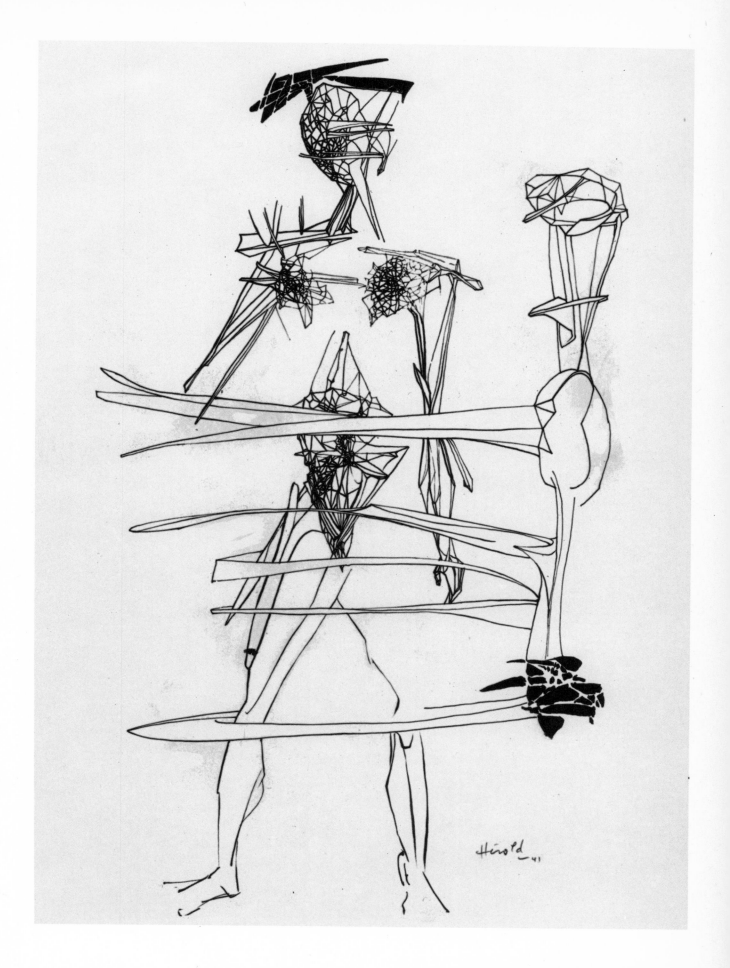

42 JACQUES HÉROLD: *Drawing*, 1941

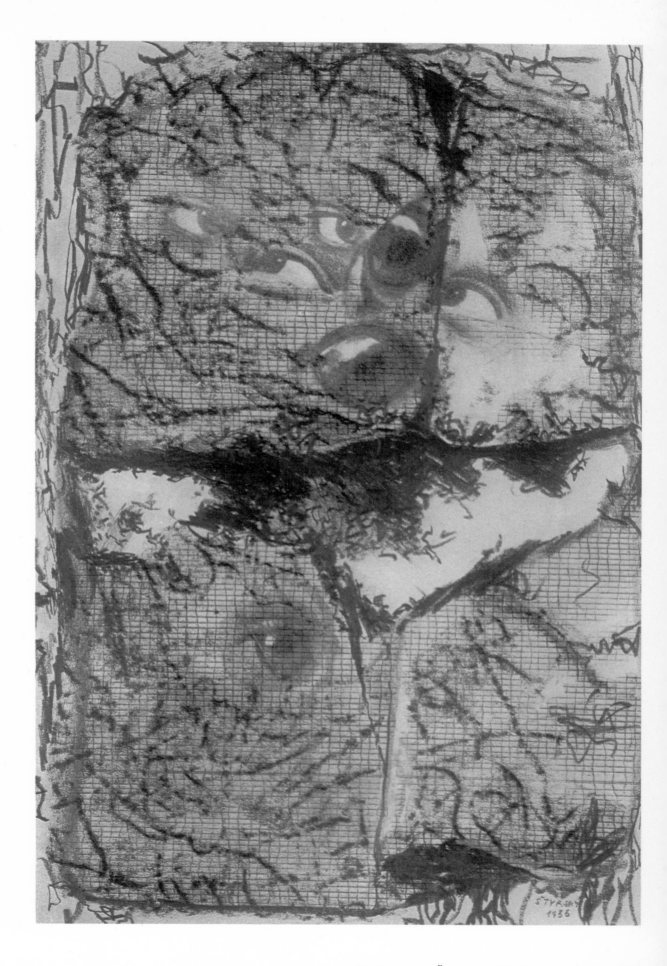

43 JINDŘICH ŠTYRSKÝ: *The Omnipresent Eye*, 1936

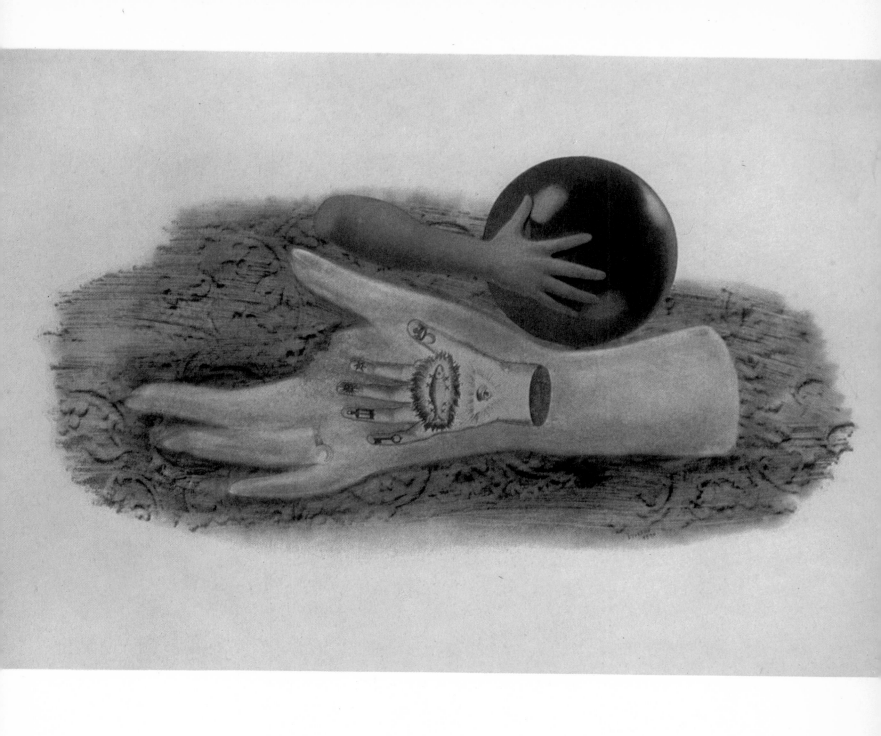

44 JINDŘICH ŠTYRSKÝ: *Drawing*, 1940

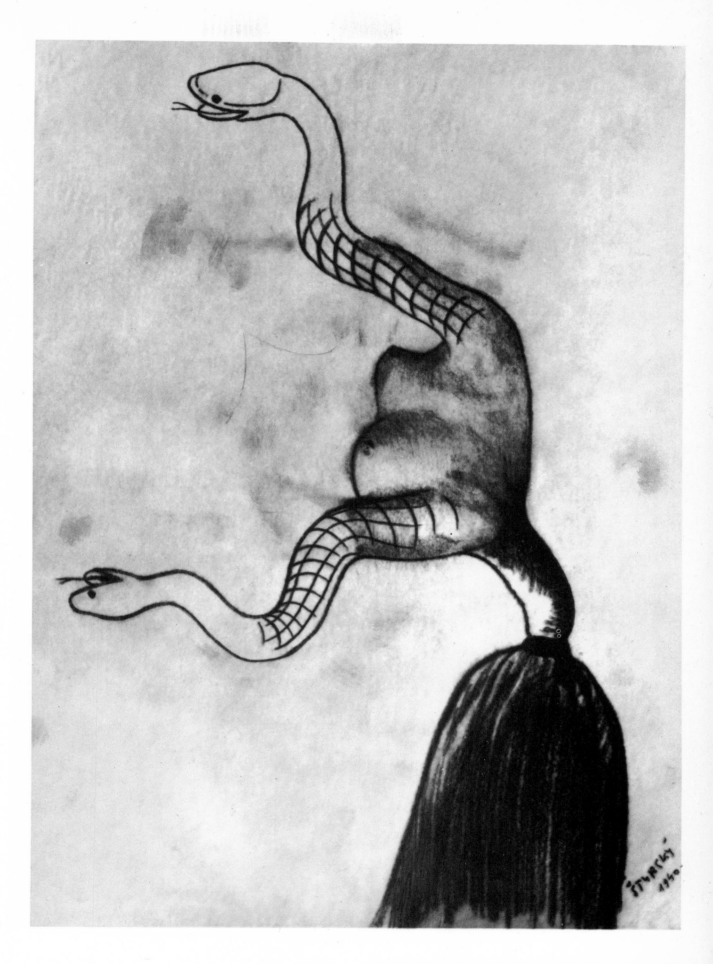

45 JINDŘICH ŠTYRSKÝ: *Dream of the Serpents III*, 1940

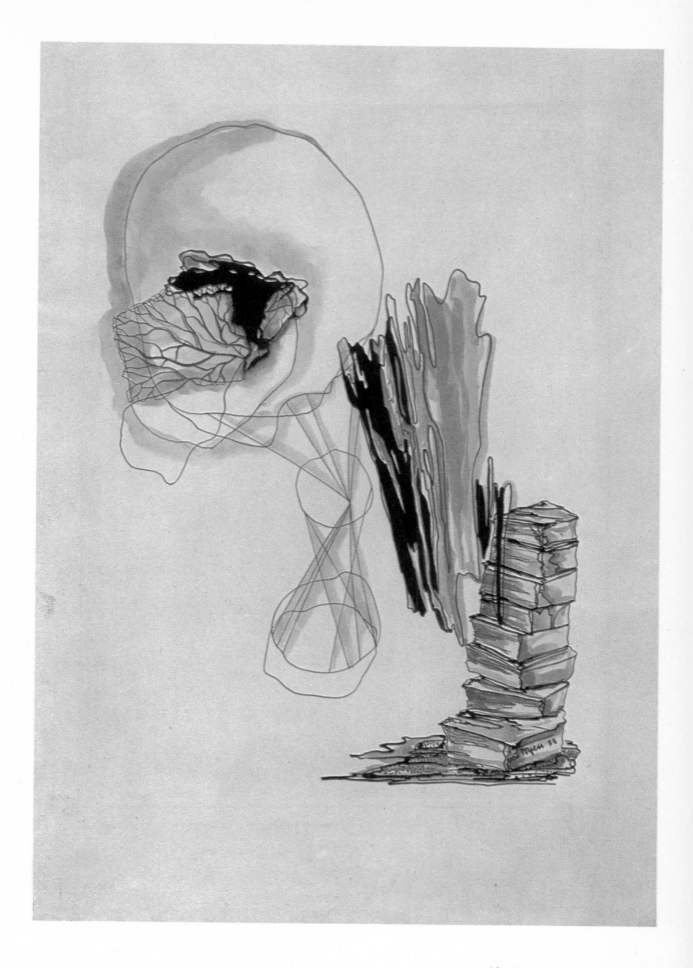

46 TOYEN: *Composition*, 1933

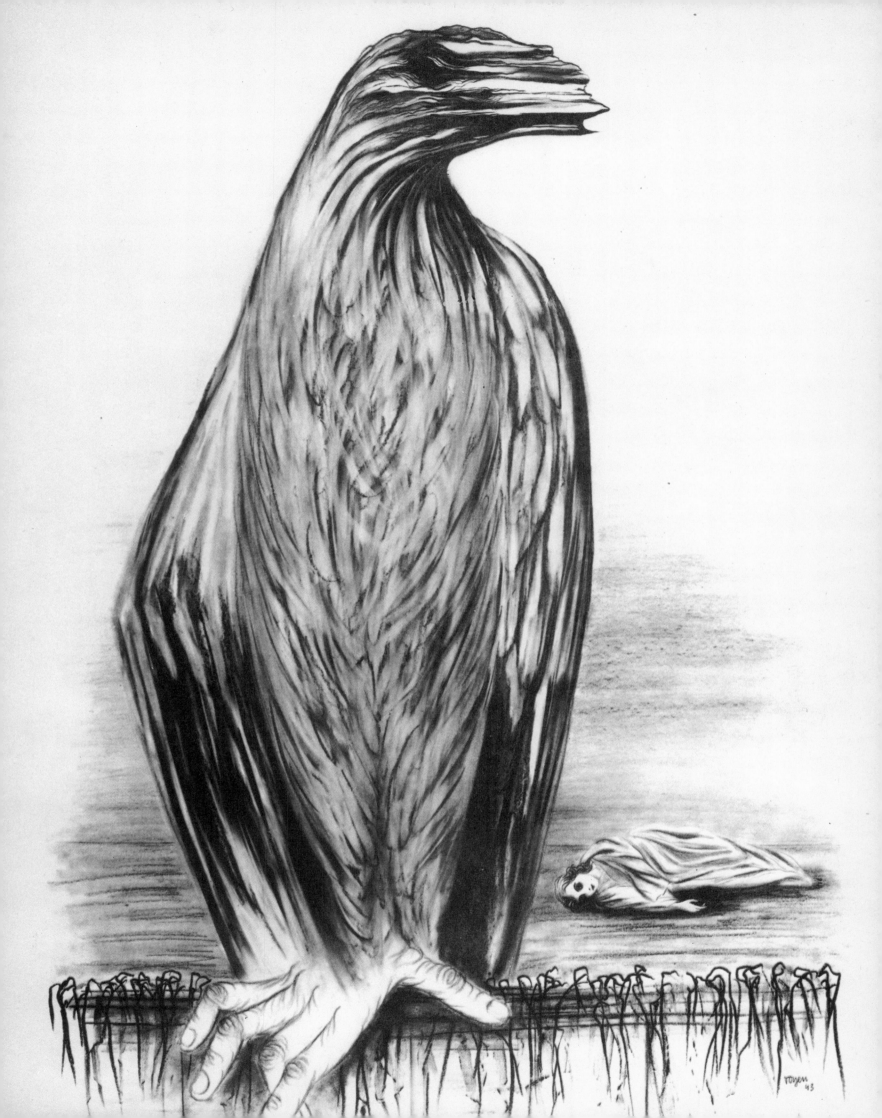

48 TOYEN: *Early Spring*, 1946

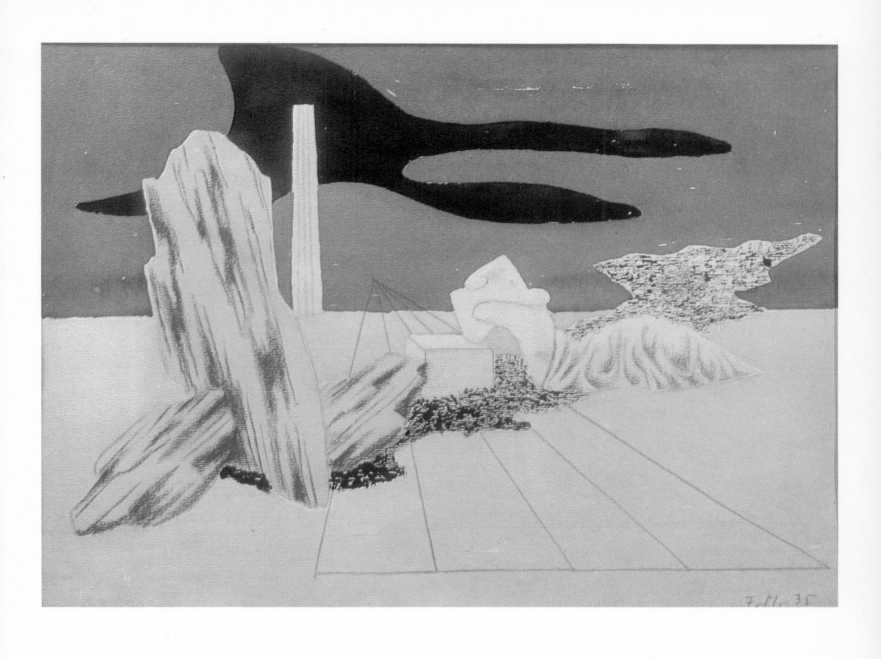

49 FRANTIŠEK MUZIKA: *Figure in a Landscape*, 1935

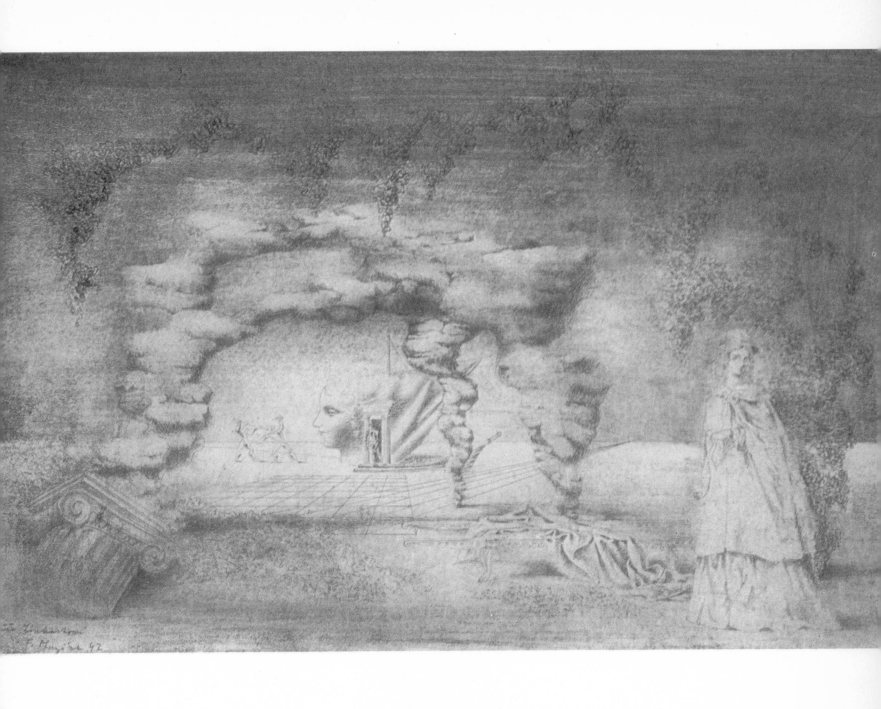

50 Frantíšek Muzika: *Great Dream*, 1942

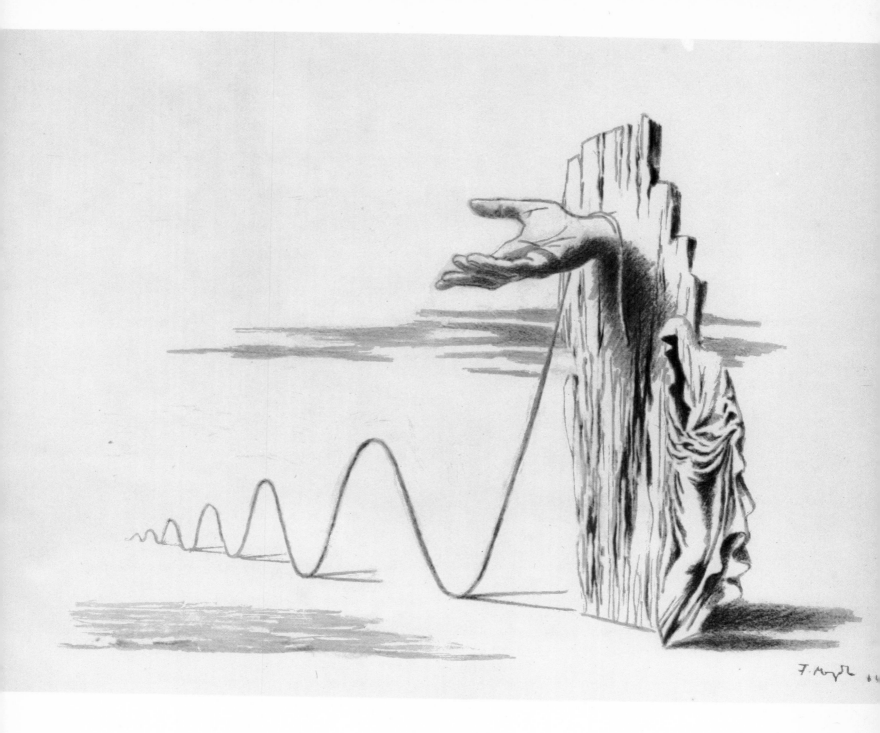

51 FRANTIŠEK MUZIKA: *Requiem*, 1944

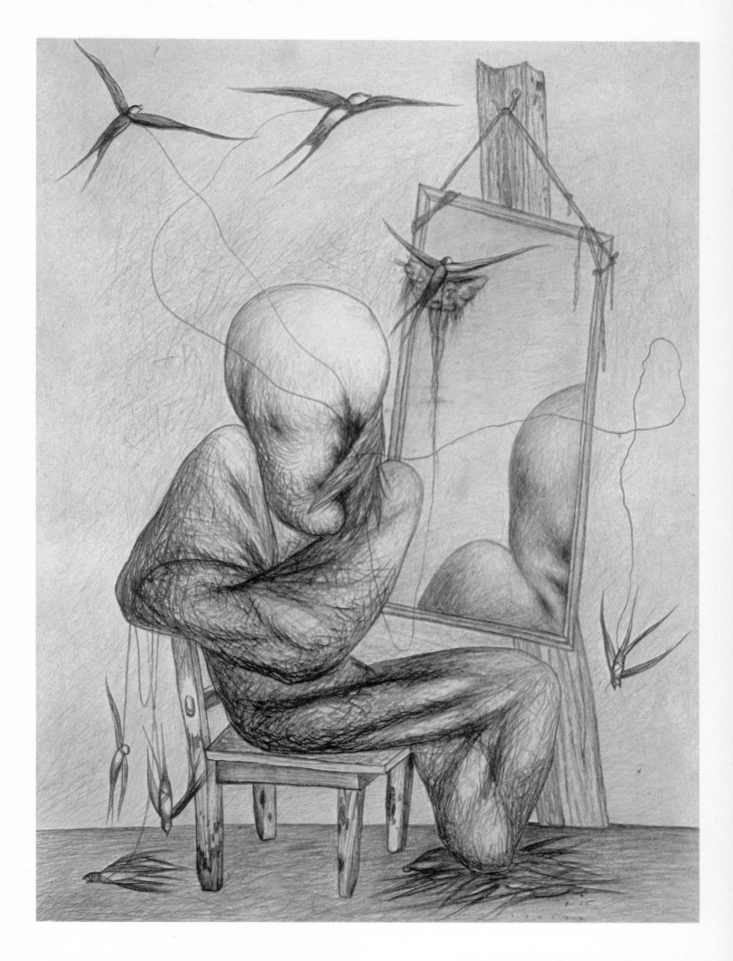

52 FRANTIŠEK JANOUŠEK: *Drawing*, 1935

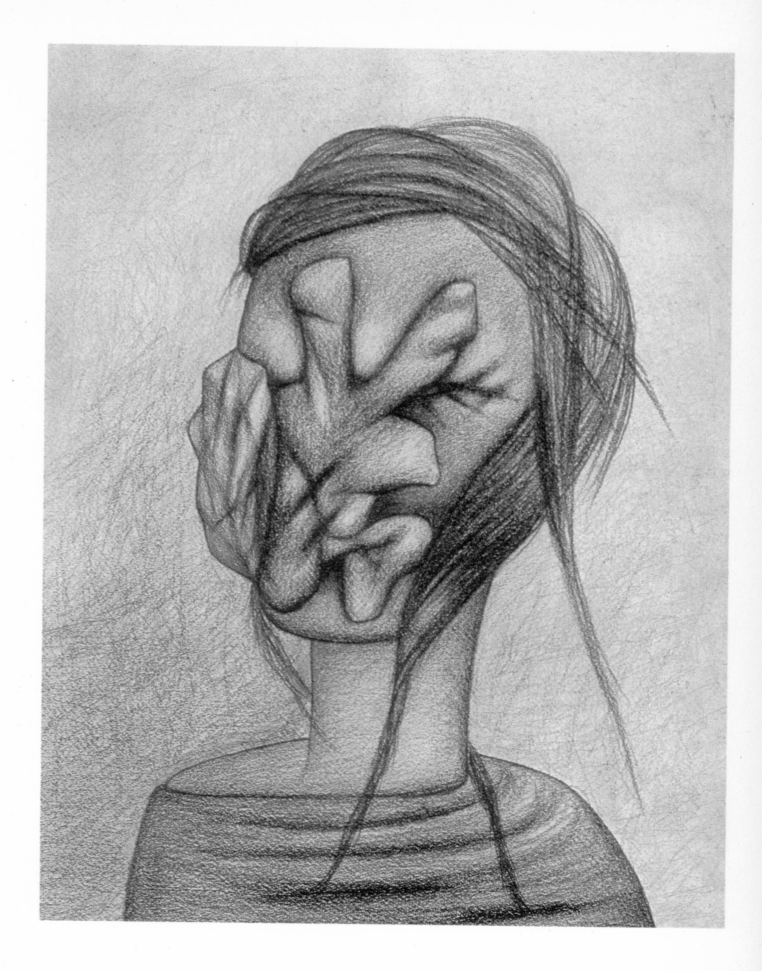

53 FRANTIŠEK JANOUŠEK: *Drawing*, 1935

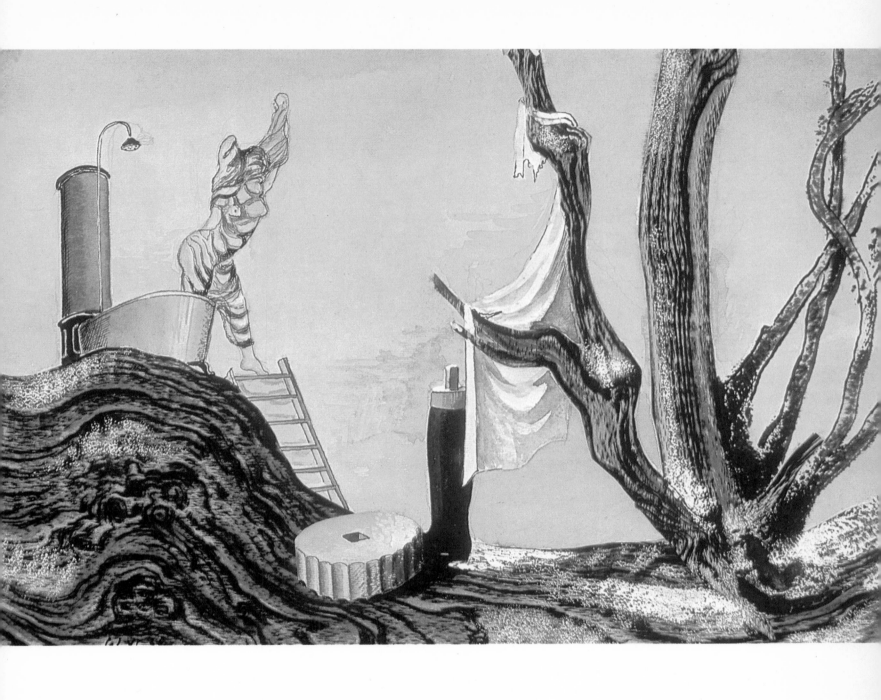

54 ALOIS WACHSMAN: *Drawing*, 1936

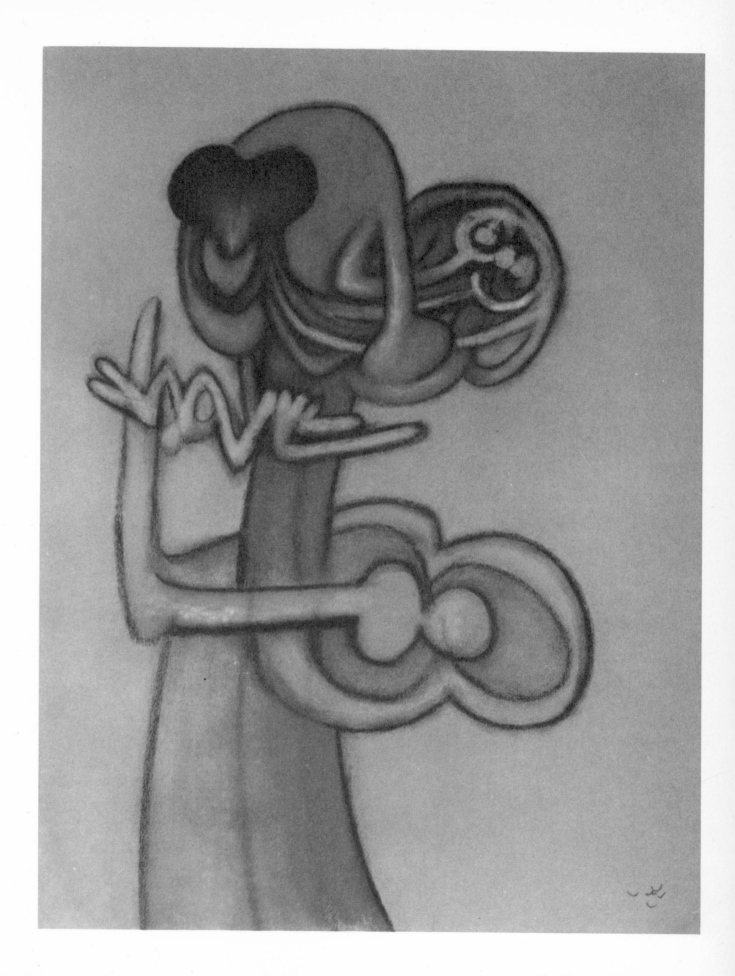

55 MATTA: *Drawing, c.* 1965

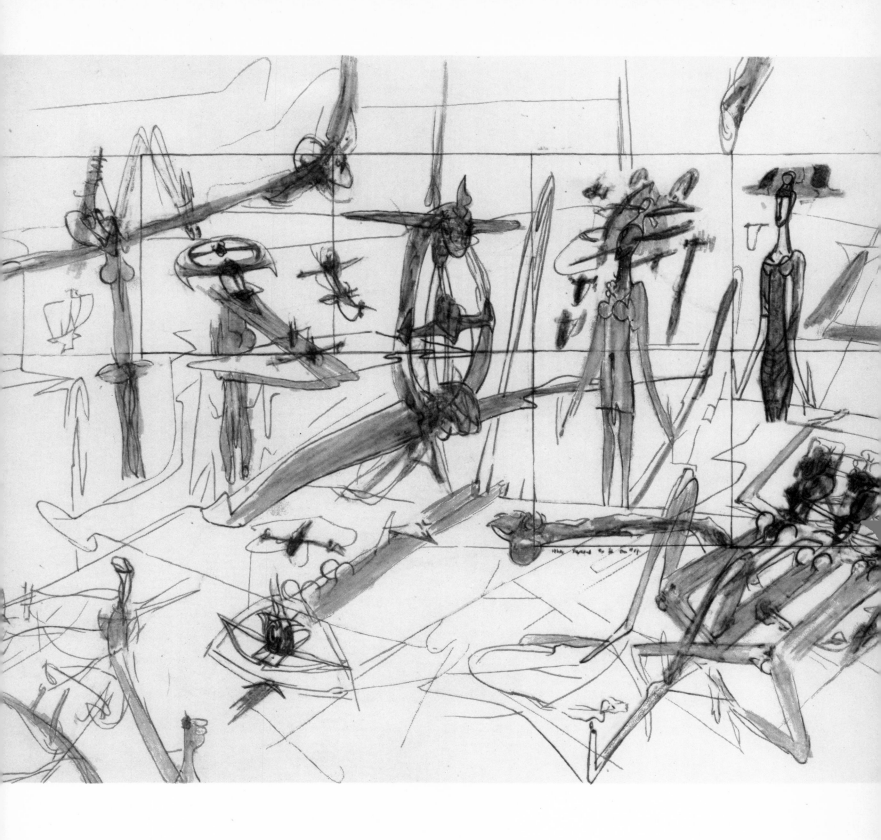

56 MATTA: *Arrête l'âge d'Hémorre*, 1948

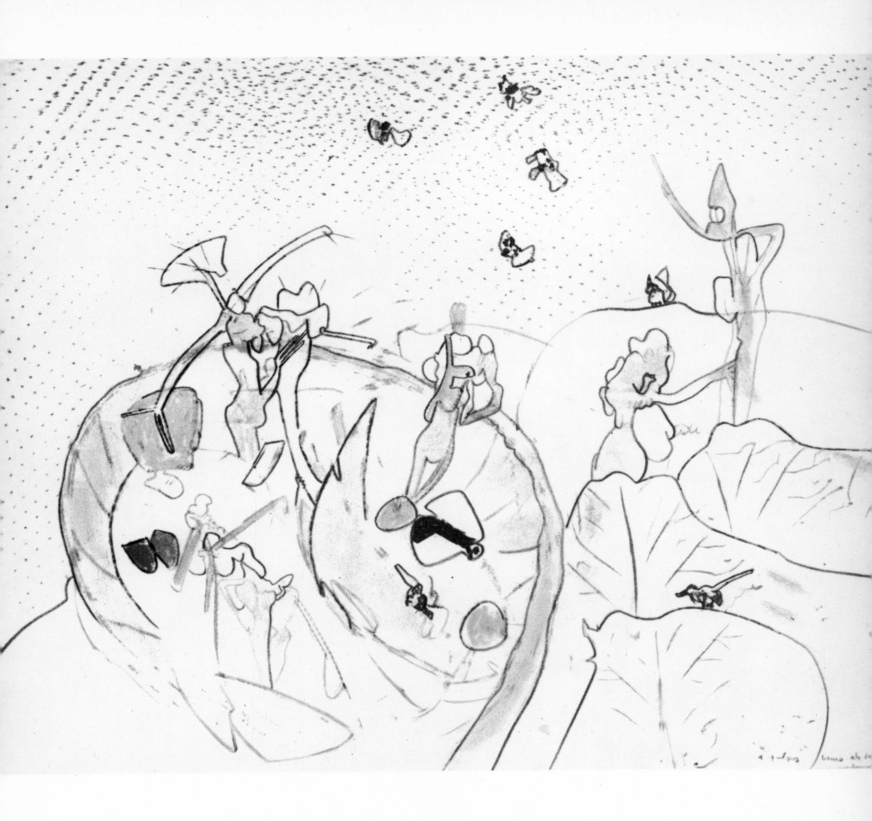

57 MATTA: *Par implosion*: "*A quelques heures de sa vie*", 1967

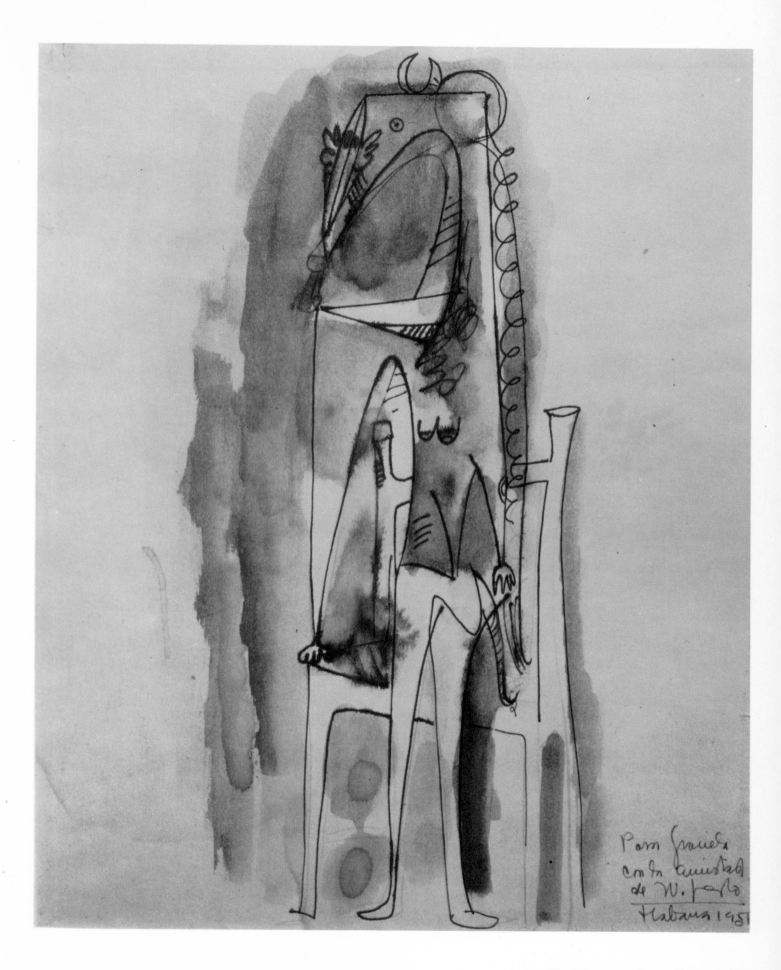

58 WILFREDO LAM: *Drawing*, 1951

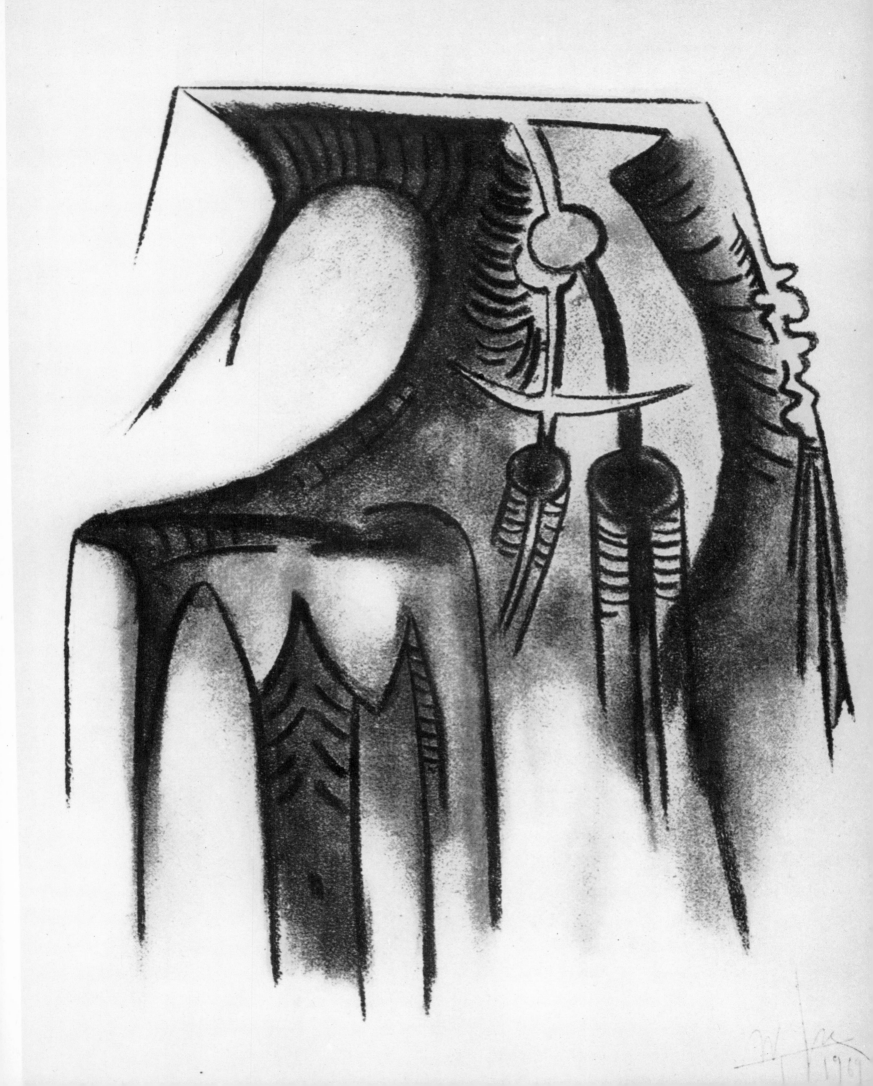

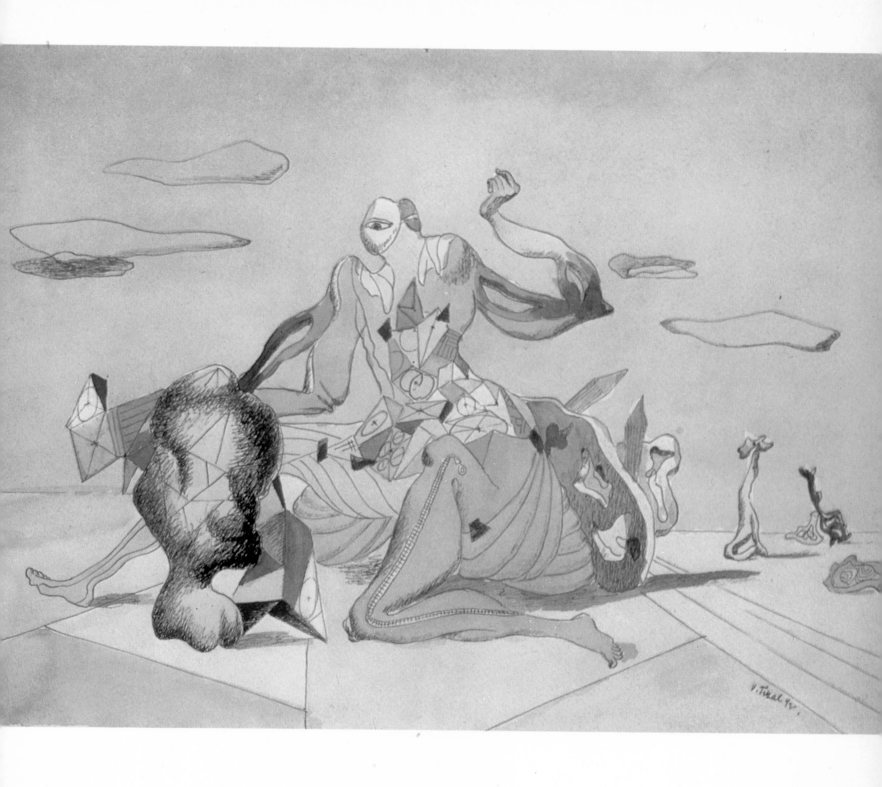

60 VÁCLAV TIKAL: *Drawing*, 1942

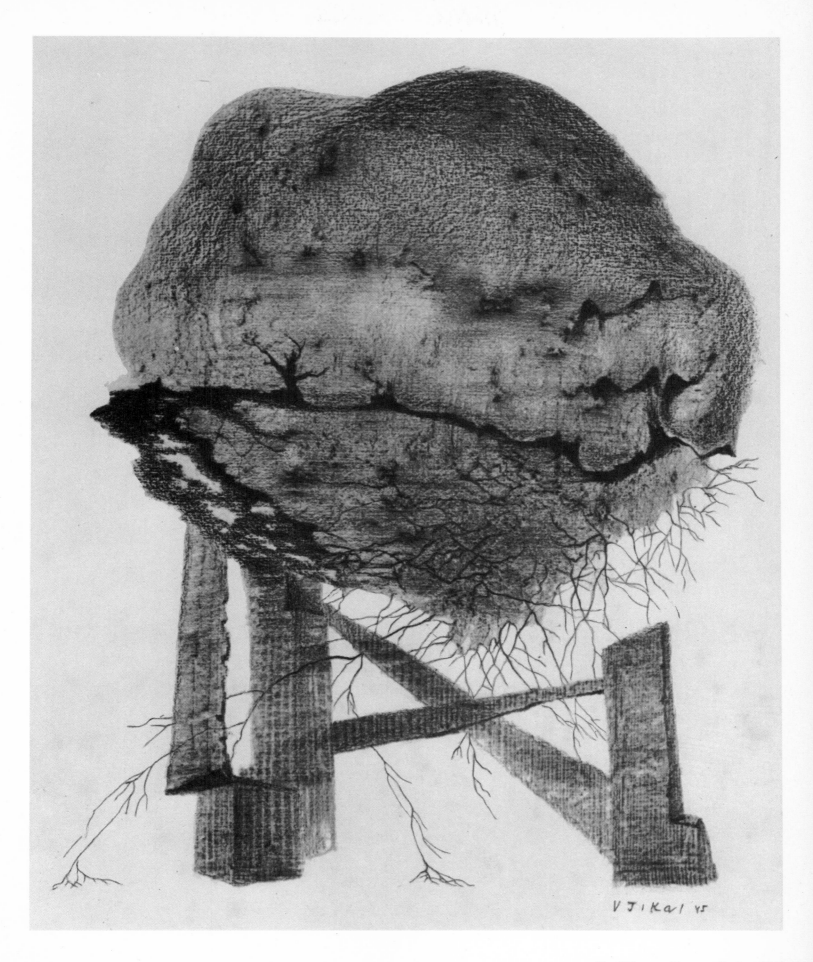

61 VÁCLAV TIKAL: *Spring*, 1945

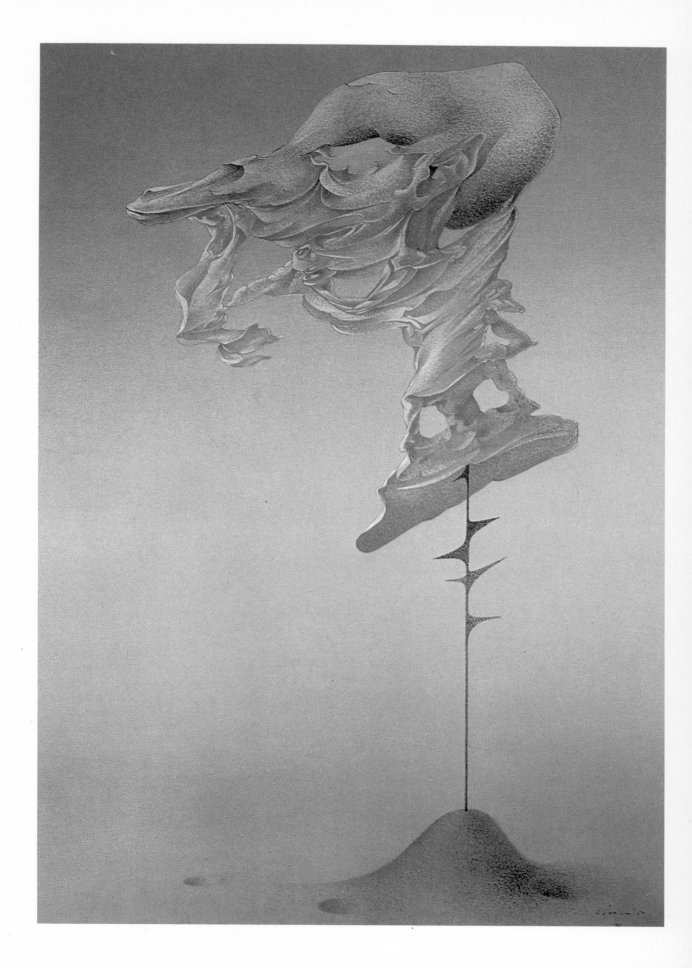

62 JOSEF ISTLER: *Nařvan I*, 1951

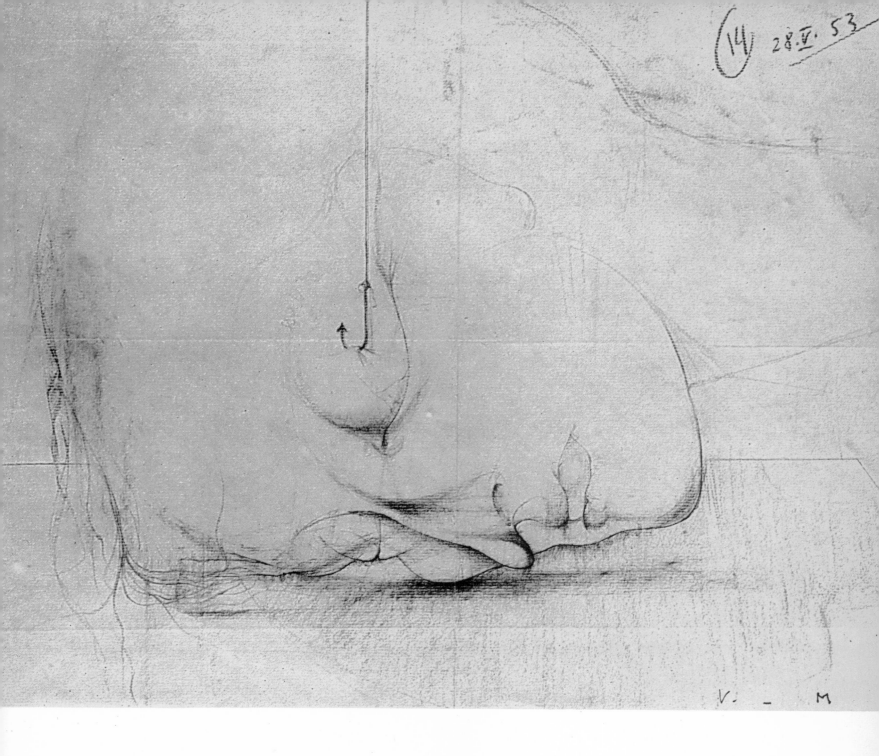

63 MIKULÁŠ MEDEK: *Head which Sleeps the Imperialist Sleep*, 1953

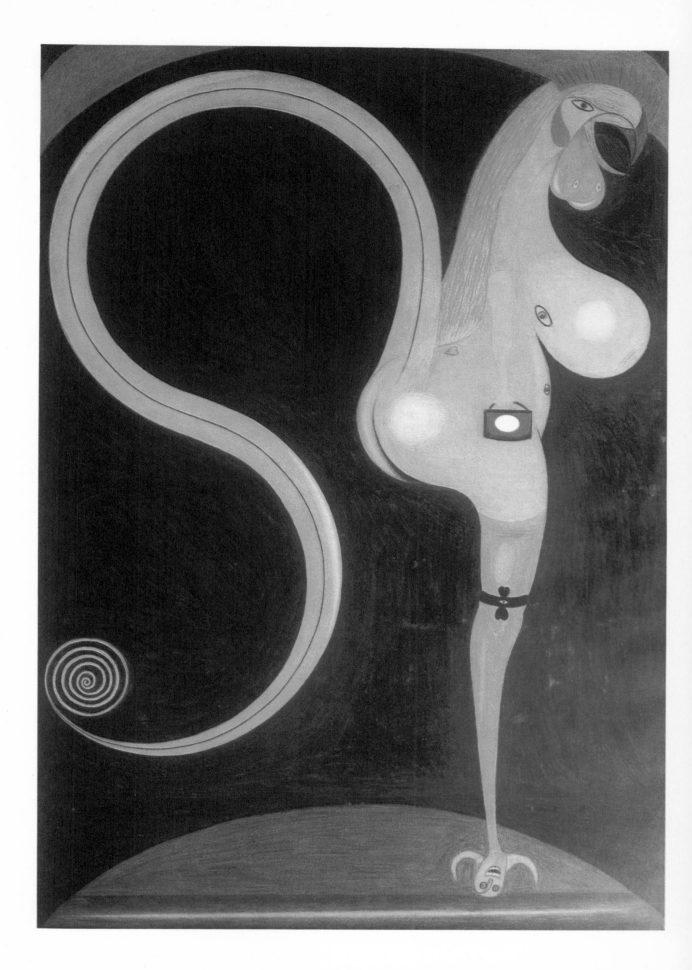

64 FRIEDRICH SCHRÖDER-SONNENSTERN: *Drawing*, 1960

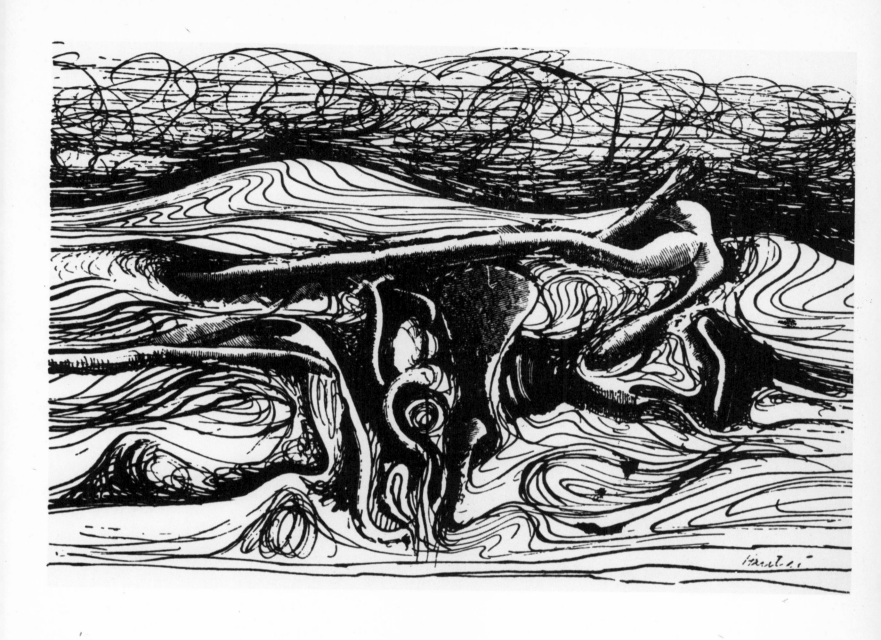

65 Simon Hantai: *Drawing*, 1953

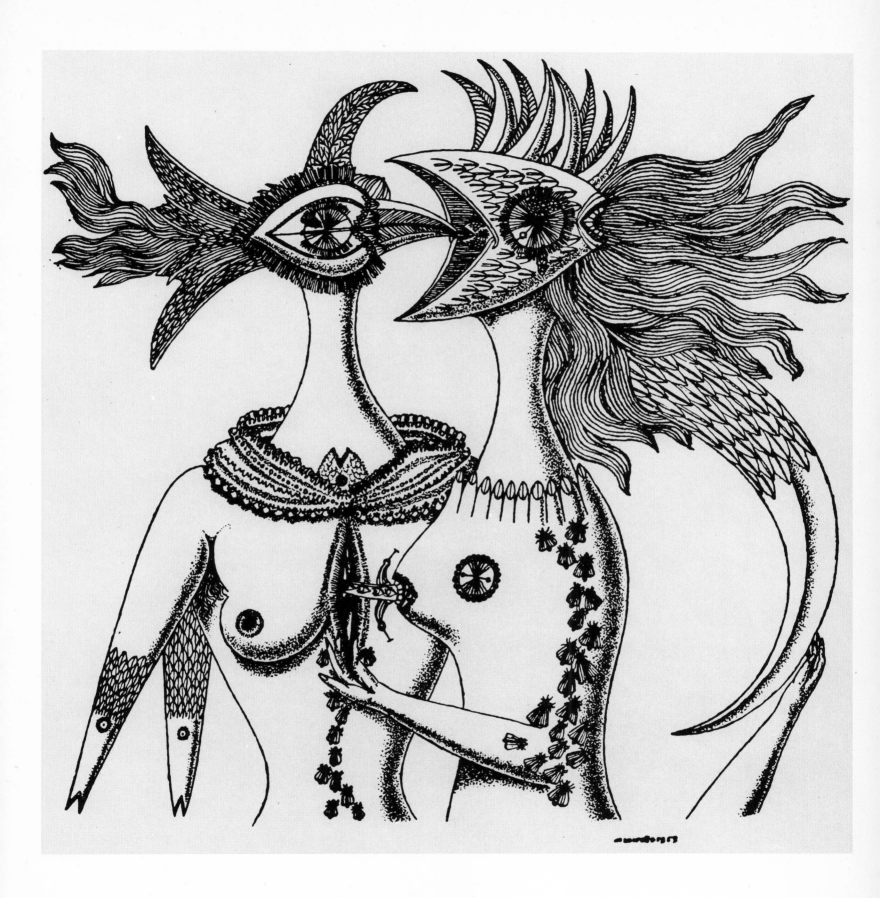

66 MAX WALTER SVANBERG: *Drawing*, 1958